A Brief History OF EASTHAM

ON THE OUTER BEACH OF CAPE COD

Don Wilding

Published by The History Press
Charleston, SC
www.historypress.net

Copyright © 2017 by Don Wilding
All rights reserved

First published 2017

Manufactured in the United States

ISBN 9781625859044

Library of Congress Control Number: 2017934935

Notice: The information in this book is true and complete to the best of our knowledge. It is offered without guarantee on the part of the author or The History Press. The author and The History Press disclaim all liability in connection with the use of this book.

All rights reserved. No part of this book may be reproduced or transmitted in any form whatsoever without prior written permission from the publisher except in the case of brief quotations embodied in critical articles and reviews.

*To my mother, Harriet Wilding, who encouraged me to write;
my son, Matt Wilding, for showing me the way down the path of history;
my wife, Nita Wilding, for her love, encouragement and support
every step of the way.*

Contents

Acknowledgements 7
Introduction 9

1. From Nauset to Eastham 13
2. Agricultural Assets: Asparagus and Turnips 23
3. The Windmill: Eastham's Landmark 29
4. The Era of "Thumpertown" 37
5. The Eastham Railroad's Golden Age 43
6. Nauset Light: The "Big Star" of Eastham 49
7. Storm Warriors: The Coast Guard in Eastham 63
8. Tales of the Eastham Rumrunners 77
9. The "Old House of Learning" 85
10. Captains of Eastham 91
11. Some Eastham Washashores 103
12. Keepers of the Cape Chronicles 107
13. Eastham, D.C. 115
14. Gateway to the Cape Cod National Seashore 119
15. Celebrating Eastham's Past 127

Bibliography 131
Index 137
About the Author 144

Acknowledgements

This book would not have been possible without the help of my friends at the Eastham Historical Society, especially Eastham 1869 Schoolhouse Museum curator Terri Rae Smith, Jim and Eileen Seaboldt, Roberta Cornish, Patty Donohoe, Jim Owens, Gloria Schropfer, Maureen Andujar and Sharen Shipley.

To my longtime comrades at the Henry Beston Society, you've all been with me on this path for many moons: Jon March, Glenn Mott, Sheila Mott, Tim Sweeney, Bob Seay and Robby "The Dune Tramp" McQueeney.

Many thanks go out to historian Bill Burke and intern Josie Mumm at the Cape Cod National Seashore; Dianne Greaney and Ron Peterson at the Orleans Historical Society; Shirley Weber, Nancy Chenoweth and the rest of the Nauset Fellowship at Chapel in the Pines; Mary McDermott; Christopher Seufert; Noel Beyle; Cape Cod Coast Guard historian Richard Boonisar; Gene Guill and Tales of Cape Cod; Tim Gerolami at the Wilkens Library of Cape Cod Community College; the staff at Sturgis Library in Barnstable; and the dozens of organizations on Cape Cod and across New England who have hosted my Cape Cod history lectures since 2001.

Many of the subjects chronicled in this book had their origins in my "Shore Lore" column for the *Cape Codder* newspaper in Orleans. Much gratitude goes out to Carol Dumas, Donna Tunney and Maureen Goodwin at the "Coddah."

Introduction

Eastham, formerly known as Nauset from 1644 to 1651, is believed to have been named for the English city of East Ham, which is located just east of London. Charles Dickens referred to it as "London over the Border."

This writer's journey to Eastham, which is referred to as "East of America" by Henry Beston, began in Clifton, New Jersey—a city of eighty thousand people—just 12 miles away from Manhattan. The shifting sands of Eastham, Massachusetts, dubbed "Cape Cod's Little Secret" by the *New York Times* in 1993, lie 286 miles to the northeast and were about as different a setting from the congested suburbs of the Garden State as one could get.

I passed through Eastham during a family trip to the Cape in 1964, but that was too far back in my memory banks to register even a blip. Not once during my eighteen years in the Garden State did I ever think I'd be so wrapped up on the outermost reaches of Cape Cod.

Much of my connection to Eastham originated through one of the most noted books about Cape Cod, Beston's *The Outermost House*. It was published in 1928 after Beston cloistered himself in a small cottage on what he referred to as "Eastham Beach" (now Coast Guard Beach) during the 1920s; I became immersed in the book in 1996. By 2000, this longtime newspaper editor was itching to publish something on it.

I was in luck. Nan Turner Waldron, my "Outermost Guru" and author of the book *Journey to Outermost House*, informed me that Eastham was planning a big celebration of its 350th anniversary in 2001, and writers were invited to submit ideas for publication. I ended up writing a Beston tribute, "On Its Solitary Dune," for the festivities.

Introduction

In charge of publications for the 350th anniversary committee was George Abbott, whose name is now on a Preservation Award given by the Eastham Historical Commission and a memorial bench at the Eastham Historical Society's Schoolhouse Museum. Abbott, who died in 2004, was the historian responsible for obtaining National Historic Registry status for several Eastham landmarks and a member of the group that created the Historical Commission. Abbott didn't mess around when it came to Eastham history. The fingerprints of George Abbott and his wife, Rosemary, were on every preservation project from Nauset Light to the Chapel in the Pines. On several occasions, the Wildings would visit with the Abbotts in their marsh side home.

I started out with *The Outermost House*, co-founding the nonprofit Henry Beston Society with my wife, Nita, in 2002. Influential as Beston was in the story of Eastham, there were so many other places to visit and soak up their stories. The Coast Guard station, a neighbor of Beston's to the north, was one of the first stops, and I had a unique opportunity to view Nauset Spit from the station's cupola on a frigid day in early 2001. One could only imagine how many shipwrecks were spotted from here, or the station's earlier incarnation, the lifesaving station, from 1872 to the 1940s.

Then there's the Nauset Lighthouse, which has guided ships since the tower was moved to Eastham from Chatham in 1923. Prior to that, the Three Sisters, which are pretty much baby lighthouses, were the beacons on the bluff. Thanks to the Nauset Light Preservation Society, this historic icon still stands, and it is open to the public for tours seasonally.

The Windmill is Eastham's oldest tourist attraction, standing majestically on the Windmill Green, across from town hall at the intersection of Route 6 and Samoset Road. During the summer, visitors file in and out, and tour buses come and go. In December, Christmas lights glow from the smock mill's arms. There's even an annual festival, Windmill Weekend, to celebrate its history.

Eastham's history extends back thousands of years. Prior to the arrival of European settlers in the seventeenth century, its longtime residents, the Nausets, called it home. The Pilgrims even had their first encounter with the natives here, days before settling in Plymouth.

The town's history also has stories of religious revivals, the arrival and departure of the railroad, an era of agricultural prosperity and becoming the focal point of one of the Cape Cod National Seashore, one of America's first seashore parks.

Introduction

As of the beginning of 2017, I've presented over 150 lectures across New England, authored *Henry Beston's Cape Cod* and am producing a documentary film on this subject. The Beston Society has also partnered with the Eastham Historical Society for an exhibit of Outermost House artifacts at the Schoolhouse Museum.

Now, the lectures have expanded to cover several different subjects. It's all part of a venture called Don Wilding's Cape Cod, a name coined by Christopher Seufert of Chatham. Its online home is at dwcapecod.com.

Over the years, it's been hard to not learn anything else about Eastham, especially when it involves meeting so many folks who have a passion for the history of the town. Many of them are gone now: the Abbotts, Don Sparrow, Kate (Moore) Alpert, George Rongner, Beverly (Campbell) Plante, Russ Chenoweth and Dave Eagles are just some of those names. To this day, I still learn something new every time I meet up with the likes of Noel Beyle, Jim Owens or Cape Cod National Seashore historian William Burke.

The stories in this book are Eastham history as I've seen it. The content and stories for "A Thorough History of Eastham," well, that would only be outnumbered by the grains of sand on Eastham's beaches.

Although I've never actually lived in Eastham, it's become like a second home. Reaching back into its extensive history, even just a little bit, is a privilege and an honor.

1
From Nauset to Eastham

It was estimated that there were about one hundred Nauset families in 1621. The 1764 census showed only four Nausets in the town of Eastham and in 1802 but one Indian was left. How sad must have been the life that solitary native, the last of the Nauset race in Eastham.
—*Alice A. Lowe,* Nauset on Cape Cod, *1968*

Nine thousand years ago, one group of people lived on the land that is now known as Cape Cod. As historian and twelfth-generation Cape Codder Todd Kelley explained, the land was more extensive then. It was actually possibly for the natives to walk from Cape Cod out to Nantucket, Martha's Vineyard and George's Bank before the sea began to fill in about six thousand years ago.

Prior to the seventeenth century, the land now known as Cape Cod belonged to five distinct tribes, all with ties to the Wampanoags. One of those tribes, the Nausets, occupied the land along the Cape's outer coast. Just to the south was the Monomoyick tribe, which resided in the area of Chatham. There were "no borders," according to Marcus Hendricks of the Native Land Conservancy. "Our borders were the rivers. We didn't really go by the months—the smell of the air, the way the animals reacted, what was going on with the earth and the water, we had our own calendar—it was based on the moon."

Their lives were simple. Families lived in small *wetus* in the summer and the larger longhouses, or wigwams, in the winter. Inside the wigwam, they'd

have a stew or chowder cooking all day. When it came to heading out on the water, *meshunes*, made of white pine or white cedar—some as large as school buses—were the primary method of transportation. Out on the water, they'd hunt for whales or seals. Spear fishing was common, too.

Around the dawn of the sixteenth century, this way of life changed forever, with the arrival of explorers from Europe. As Kelley put it, the natives' stable life was undermined. "It isn't like the Europeans had this diabolical plan, it was more of a series of events that led to the collapse of the communities here."

Whether the Vikings landed on the Cape is a subject debated by historians—the name "Wonderstrand" was allegedly bestowed on this region by the Norsemen over one thousand years ago. When John Cabot and his crew began hauling in large catches of codfish around the peninsula in 1497, more explorers and fishermen were in the nearby waters. The natives often spotted their vessels, which Hendricks said that they referred to as "floating islands."

Bartholomew Gosnold was one of the first explorers, hauling in such an abundant cod catch near Provincetown that he dubbed the peninsula "Cape Cod." Much of Gosnold's exploration, however, was farther up on the Cape.

According to William Nickerson's unpublished 1933 manuscript, "Some Lower Cape Indians," there were no European settlements anywhere along the North American seaboard from the St. Croix River in Maine to the St. Johns in Florida. That summer, the French explorers Samuel de Champlain and Sieur de Monts set sail from the area of the Canadian Maritimes and anchored in what is now Nauset Harbor, which, in turn, is connected to the Salt Pond in Eastham and the Town Cove on Eastham's southern border with Orleans. For a week, the French vessel stayed there, with Champlain observing the activities of the Nauset village ashore. The hillsides overlooking the marsh were dotted with Nauset wetus.

Champlain was intrigued, and he set about sketching the village and harbor. He named the area Malle-barre and landed on the beach north of the inlet, where they met the first Nausets. "We found the place very spacious, being perhaps three or four leagues in circuit, entirely surrounded by little houses, around each one of which there was as much land as the occupant needed for his support," Champlain observed. "There were also several fields entirely uncultivated, the land being allowed to remain fallow....[T]heir cabins are round, and covered with heavy thatch made of reeds."

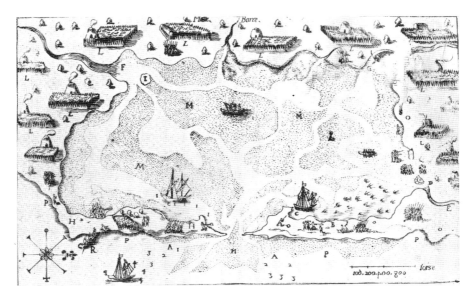

A map of the Nauset natives' settlement, sketched by French explorer Samuel de Champlain during his visit in 1605. *Eastham Historical Society.*

Over the last few centuries, the size of the barrier beach that separates the Atlantic Ocean from Nauset Harbor and Marsh has decreased significantly. As recently as the early twentieth century, the barrier beach north of the inlet was three to four miles long and nearly a quarter of a mile wide, with towering dunes. By early 2017, the northern portion of the beach was reduced to just over a mile long, about one hundred yards wide, and mostly flattened, with only a small dune area near the east-facing beach. The inlet also migrates from south to north over time. When the inlet reaches the farthest northern point of the barrier beach, a new one opens to the south near the border of Orleans. The harbor that Champlain sailed into over four hundred years ago is significantly smaller now than it was then.

Unfortunately for the Frenchmen, a dispute over a kettle led to the first bloodshed and fatality of a European visitor on Cape Cod shores.

Even with this major misunderstanding, the Frenchmen were able to patch up their differences with the Nausets. They went north on the beach, then westward, across the land that would later become Deacon John Doane's farm. Fields of corn and tobacco were abundant. They sampled the Indian beans and squashes and saw the fish weir on the north side of the marsh.

A Brief History of Eastham

The French visitors didn't stay for long, but they returned a year later. This time, Champlain was traveling with Sieur de Poutrincourt and stayed at Nauset only briefly. Champlain and de Poutrincourt then sailed south, but the ship ran into trouble off Pollock Rip (Chatham Bar) and somehow worked its way into Stage Harbor (known to the Monomoyicks as Seaquanset). Relations with the Monomoyicks there were initially good but quickly soured within ten days, and two of the explorers were killed. Initially dubbed Port of Fortune, it wasn't long before other names were bestowed on the Chatham harbor, including Place of Mishappenstance. De Poutrincourt had a fur trade monopoly going on in Nova Scotia, and that was stripped from him because this trip was such a disaster. French explorations south of Nova Scotia ceased after this point.

More trouble erupted following a visit by Captain John Smith in 1614. According to Nickerson, while his two ships gathered fish, Smith explored Cape Cod Bay in a small boat near Provincetown. He returned to England with the first ship full of fish, while the other one stayed to fill up with dry fish and head to Spain. Thomas Hunt was left in charge, and "he abused the savages where he came, and betrayed twenty-seven of these poor innocent souls, which he sold off for slaves in Spain." It's believed that the seven from Nauset never returned.

In 1616, a French ship was wrecked near Pawmet, with three or four survivors, and they were captured and tortured by the Nausets. One of the Frenchmen survived and eventually married the daughter of Aspinet, the Nauset chief. They had a child but perished in what was known as the Great Plague of 1616–18.

"It's a significant part of the story that isn't told about enough," Kelley explained. "That happened from Maine to Narragansett, but probably didn't on the Cape. It could have been measles, bubonic plague, yellow fever—something that the native people had no resistance to. European settlers had been coming around the area. When that came along, thousands of people just died, and their bones were just left there."

Tisquantum, or Squanto, one of twenty prisoners taken at Plymouth, regained his freedom in Europe and returned to Pawtuxet, only to find his people gone. Fluent in both English and the tribal languages, Squanto became a critical link between the two cultures before his death in 1622.

The Pilgrims were the next visitors from England to settle in the area. Their vessel, the *Mayflower*, approached Cape Cod in November 1620. As the *Mayflower* approached the Cape, it approached Pollock Rip and found itself near the shoals, courtesy of a strong northerly wind. Fortunately for

the ship, the wind eased and shifted to the south—"a good, strong lifesaving breeze," as noted by W. Sears Nickerson: "Captain [Christopher] Jones praised the Lord, swung his ship's head around, squared his yards before it, and clawed her out through the treacherous rips into the blue water beyond. Before sundown he had her back off Chatham and hove-to for the night, with plenty of water under her keel."

As Nickerson noted, "Hudson River country" was the Pilgrims' destination, but life aboard the *Mayflower* was becoming more difficult by the day. Provisions, including fresh water, were dangerously low, and the firewood was gone. Two of the *Mayflower*'s party had already succumbed to illness. "This was but the beginning of that deadly malady which put nearly fifty per cent of the crew and passengers into their graves before spring," Nickerson wrote. Captain Jones survived and returned to England on the *Mayflower* several months later, but he died shortly thereafter.

Jones consulted a map from Captain John Smith that showed a harbor, Milford Haven (what is now Provincetown Harbor), just to the north. With the dire conditions on the ship and favorable conditions for sailing, Jones headed in that direction. As Nickerson wrote:

> *It was high tide at Nawset about nine o'clock which means that the* Mayflower, *squaring away at sunrise from her night's berth off Chatham just north of the Shoals, ran right into a high tide and held it until sunset. Knowing her average rate of speed, I do not see how even a fair wind could have pushed her against it much farther than somewhere just north of High Head in Truro before nightfall. Thus it is quite possible the Pilgrims watched the sun go down that night behind the hill in Provincetown where some three centuries later a grateful posterity would erect a Monument to their memory.*

The *Mayflower* eventually anchored in the harbor, and the Pilgrims signed the Mayflower Compact on November 11, 1620. They didn't stay on the Outer Cape for long, opting to settle across the bay in an area they would name Plymouth. Before leaving the Cape, the Pilgrims sent a group of explorers south into Nauset territory, resulting in a brief skirmish with the Nausets that would forever be remembered as the "First Encounter." By 1620, tensions were still running high among the Nausets and other tribes when it came to European visitors. Accounts of what route the *Mayflower* passengers, or "Old Comers," as William Bradford called them, took to get there vary, but Nickerson noted that Myles Standish and his men never saw one Indian on the way.

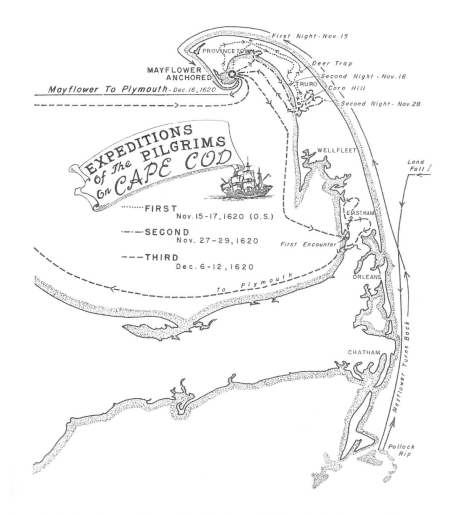

A map indicating the expeditions of the Pilgrims, which includes the journey to First Encounter Beach in Eastham before the explorers settled across Cape Cod Bay in Plymouth. *Cape Cod National Seashore.*

On the morning of December 8—"twilight in the morning," as described by William Bradford—Standish and his men were greeted by the war whoop of the Nausets and a flurry of arrows. Still well aware of what happened with Thomas Hunt and some of their fellow tribesmen six years earlier, Aspinet and the Nausets remained hostile to any outside visitors. As William Bradford wrote, "The cries of ye Indeans [*sic*] was

On the Outer Beach of Cape Cod

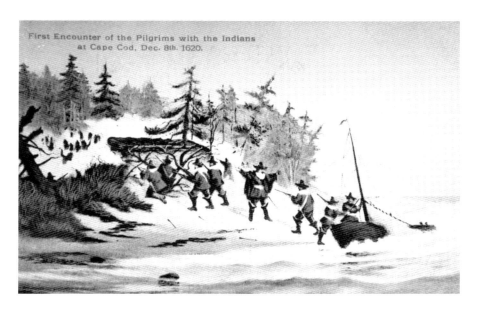

Postcard depicting the "First Encounter" conflict between the Nausets and Pilgrims along Cape Cod Bay in Eastham. *Eastham Historical Society.*

dreadful. Their notes was after this manner…'Wooach! Wooach! Ha! Ha! Wooach!'" According to Nickerson, the attack happened "on the point of land near the landing place on the north side of the mouth of the Boat Meadow Creek." Neither side suffered casualties. Eighteen of the arrows were rounded up and sent to England.

In 1920, a plaque was placed on the site: "On this spot hostile Indians had their first encounter December 8, 1620, old style, with Myles Standish, John Carver, William Bradford, John Tilley, Edward Winslow, John Howland, Edward Tilley, Richard Warren, Stephen Hopkins, Edward Dotey, John Allerton, Thomas English, Master Mate Clark, Master Gunner Copin, and three sailors of the Mayflower Company."

A new plaque was erected in 2011:

> *Near this site the Nauset Tribe of the Wampanoag Nation, seeking to protect themselves and their culture, had their First Encounter 8 December 1620 with Myles Standish, John Carver, William Bradford, Edward Winslow, John Tilley, Edward Tilley, John Howland, Richard Warren, Stephen Hopkins, Edward Dotey, John Allerton, Thomas English, Master Mate Clark, Master Gunner Copin and three sailors of the Mayflower Company.*

A Brief History of Eastham

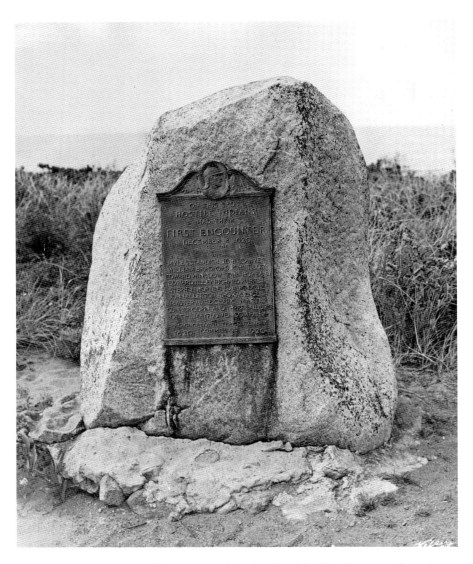

Monument on the bayside of Eastham, marking the site of the First Encounter. It reads: "On this spot hostile Indians had their first encounter December 8, 1620, old style, with Myles Standish, John Carver, William Bradford, John Tilley, Edward Winslow, John Howland, Edward Tilley, Richard Warren, Stephen Hopkins, Edward Dotey, John Allerton, Thomas English, Master Mate Clark, Master Gunner Copin, and three sailors of the Mayflower Company." *Eastham Historical Society.*

Peace between the Nausets and settlers came the following summer. John Billington, a juvenile prone to trouble, was lost in the woods, and Indians took him to Nauset. As Nickerson wrote:

> *The governor sent the shallop for him, and she lay aground at Nauset on the ebb tide, Aspinet came and brought the boy with him, one of his men bearing the lad through the water on his shoulders. There were another hundred Indians present. There he delivered us the boy, bestrung with beads, and made peace with us, we bestowing a knife on him, and likewise on another that first entertained the boy and brought him thither.*

In 1643, arrangements were made for the Nauset Purchase, and the following year, forty-nine people from Plymouth, unhappy with their lives there, settled in Nauset. "Affairs at Plymouth had not been prospering as formerly," according to Alfred Alder Doane's *The Doane Family and Their Descendants*. "There was not sufficient upland. There was without doubt a slight division in the church, which made those persons of similar minds and ambitions to think of removal to Nauset."

The heads of seven families—Thomas Prence, Deacon John Doane, Nicholas Snow, Edward Bangs, Richard Higgins, John Smalley and Josias Cook—known as "The Purchasers," sailed across Cape Cod Bay in the sloop *Swan*. The newly christened town, which originally reached from Bass River to Provincetown, became known as Eastham in 1651. The town was likely named for its English counterpart, East Ham. The Nauset territory purchase payment to the Indians consisted of "moose skins, Indian boats, wampum, and little knives."

Prence, whose name is also spelled "Prince" in early writings, was the governor of the Plymouth Colony and lived in a house located at the corner of what is now Route 6 and Governor Prence Road from 1644 to 1663. Prence served as governor from 1634 to 1635 and 1638 to 1639 and again from 1657 until his death in 1673.

Doane settled on a plot of land north of Town Cove, near Nauset Marsh. A granite post was erected on the site of the house in 1869, on what was open land until the mid-twentieth century. A guided trail within the borders of the Cape Cod National Seashore takes visitors through the wooded area that is there today. He was fifty-five when he made the move to Nauset and was described by Alfred Doane as "a prominent man in Plymouth" after arriving there from England around 1630. Alfred Alder Doane suggested that "his business ventures in common had not been successful." Doane was

appointed by the court in 1663 to administer oaths to witnesses, was deacon of the first church and served as a town selectman for many years.

The property obtained in the Nauset Purchase belonged to the Purchasers, along with seven additional Purchasers who were appointed by Bradford: Daniel Cole, Job Cole, John Freeman, Samuel Hix, John Jenkins, Joseph Rogers and Robert Wixam. As the Eastham Historical Society noted in its report, "Old Comers and Purchasers in Early Eastham History," "There was an active real estate market in the 1600s and parcels frequently changed hands."

The appointment of Samuel Treat as pastor in 1672 brought more of the Nausets into the Christian fold. Treat, who died in 1717, is generally acknowledged as the town's first minister, and according to the Eastham Cemetery Commission, he was "distinguished for his evangelical zeal and labors, not only among his own people, but also among the Indians in this vicinity; and he was the instrument of converting many of them to the Christian faith." Treat, a native of Milford, Connecticut, and a 1699 graduate of Harvard College, was "remembered as preaching hellfire and damnation. His voice was so loud that when speaking it could be heard at a great distance from the meetinghouse, even in the midst of the winds that howled over the plains of Nauset." According to the Eastham Historical Society, the site where the Cape Cod National Seashore's Salt Pond Visitors Center stands was known as Treat's Hill, and it was land set aside for the natives.

As their numbers decreased, the Nausets declined to participate in King Philip's War in 1675. It was during these years that the culture changed. Many natives converted to Christianity and married members of other races. Along with changes to the landscape, the Nauset lifestyle was gone forever.

"After the plague, the trees, which were the size of redwoods, were being stripped down and brought over to King James. Much of it was used for burning," Hendricks noted. "Anything that was more than three feet wide was considered his."

The vast area known as Eastham began to shrink over the years. First Harwich incorporated as a town in 1694, followed by Truro in 1709, Chatham in 1712, Provincetown in 1727, Wellfleet in 1763 and Orleans in 1797.

2
Agricultural Assets

Asparagus and Turnips

We were the asparagus and turnip kings of the east, Eastham was.
—Arthur "The Turnip Man" Nickerson, 1994

Since 1940, Eastham has primarily been known as a tourist destination. It might be hard to believe, but prior to that, Eastham was the agricultural center of the Outer Cape, especially known for asparagus and turnips and, to a lesser degree, corn, dairy and cranberries.

According to Kathryn Grover's 2005 Eastham Historic Properties Survey Project, "Automobile-Age Tourism in Eastham, 1900–1960," 58 percent of Eastham's 1900 workforce was in agriculture, but that number had declined to only 21 percent by 1930.

Corn was introduced by the Nausets and other tribes to the earliest English settlers. Eastham was among the leading corn-producing communities on the Cape for several years, but its output had begun to decline by 1880. According to Grover's report, "[G]rain farming, combined with decimation of the original oak and pine timber for fuel and shipbuilding, wore and blew away the natural light and sandy soil."

During the late 1800s, boosted by the presence of the Old Colony Railroad, dairy was big business, with Ezekiel Doane, Seth Knowles and Reuben Nickerson ranking among the town's leading egg producers. In a 1994 interview with the Eastham Historical Society, Arthur Nickerson recalled dairy farms on Governor Prence Road, Nauset Road and Fort Hill.

A Brief History of Eastham

Alice Lowe noted in *Nauset on Cape Cod* that Eastham's railroad depot "became the center of activity. Several men who conducted dairy or chicken farms, began to use the new railway express service for sending their milk to dealers in Provincetown or their eggs to Boston." Grover noted, "[N]ever were more cows counted in Eastham than in 1885."

As the twentieth century dawned, dairy business began to shift off-Cape, forcing the peninsula's farmers to adapt once again. Their endeavor, Grover wrote, "would depend [on], in order of value, asparagus, turnips, and cranberries," but cranberries were clearly a distant third behind the two vegetables. Asparagus and turnips thrived in Eastham's sandy soil.

At first, asparagus was the agricultural king of the late nineteenth and early twentieth centuries. In 1898, E.G. Perry wrote in *Trip Around Cape Cod*, "Eastham farmers are busy and successful raising asparagus or 'parrergrass,' or 'grass' for short, as some call it." A "rust-resistant strain of asparagus was quickly planted after a fungus decimated the crop in 1901," according to Grover, but the crop quickly rebounded. By 1920, 150 acres of asparagus beds dotted the Eastham landscape, and that number rose to 230 acres by 1930. In 1932, Arthur Wilson Tarbell dubbed Eastham "Asparagus Acres," noting that the farmers' gross returns was about $400 an acre, "a good investment for three months labor."

Asparagus was an early season crop, with most of it harvested by the Fourth of July. In 1962, the *Boston Globe*'s Earl Banner wrote that during the early 1900s, "the nation's best asparagus was grown in Eastham in such quantity that, during the cutting season, two or three solid carloads of the delicious stuff was shipped up to Boston market six days a week over the tracks of the Old Colony Branch." In 1951, Maurice Wiley told the *Cape Codder* that asparagus was on every lot of available land. "Years ago a fellow with a cow, a pair, and a few hens and some good growing soil got along alright; he worked two months of the year and made enough to keep himself and his family all year."

Adults weren't the only agricultural laborers on Cape Cod; children were often enlisted to help out in the fields. In an interview with the Eastham Historical Society, Fenton Sparrow recalled how much he disliked the asparagus harvesting season—not so much for the work, but because it conflicted with "May Basket Time." "During the asparagus season, we used to get up at 4:30 or 5 o'clock in the morning, cut the asparagus, rush home, have a big breakfast of bacon and eggs, and then go to school," Sparrow recalled. "Getting up at 5 o'clock in the morning and going to May Basket parties and staying out until 11 or 12 at night" proved to be exhausting, he said.

In 1993, Arthur Nickerson was one of the few Eastham residents still growing asparagus, using many tools that were at least seventy-five years old. As Ken Seaman reported in the *Cape Codder* in 1993, Nickerson was still using asparagus soakers, which were "about three feet by seven feet and have a four-inch high board around them to keep the water on the asparagus." Nickerson said that he would let the asparagus soak until evening, then bunch and package it in crates. Trucks would then pick up the produce at night and take it to market in Providence or Boston.

However, once again, the off-Cape market took charge, asparagus prices dropped and local farmers became more dependent on the Eastham turnip, which was always coveted for its unique flavor and sweeter taste. It was the perfect follow-up crop for asparagus, as it was harvested in late September and October. Climate and soil conditions were ideal for growing white turnips, which are sold both on the Outer Cape and in Providence, the *Cape Codder* reported in its September 27, 1951 edition:

> *Although turnips produced locally are known generally as the "Eastham turnip," various growers have produced the "Bristol White," "Macomber," and "White French" varieties. In past years, some growers have raised their own seed developing their own characteristics, with varieties of purple, green and even pink tops.*

Ellen Petry Whalen reported in the September 2009 edition of *Edible Cape Cod* that Charlie Horton of Orleans "passionately believed the (Eastham) turnip is descended from Scotland's version of the turnip, called a neep." The seed dated back to the late nineteenth century, reported William Donaldson for the *Cape Codder* in 1986. "It was normal turnip seed back then, but it was transformed into one of Cape Cod's finest delicacies through generations of growing in Eastham's sandy soil. Clay soil yields the more bitter-tasting product commonly found in most grocery stores."

In the 1900s, fertilizer made from fish was often used, which Arthur Nickerson believed was much more beneficial than chemical fertilizers. As an industrious youth during the Depression era, Nickerson, who grew up on his father George Nickerson's seventeen-acre farm, "borrowed a piece of land" off of Whepley Road to farm turnips for "spending money."

During the late season harvests, farmers often pulled the turnips and covered them with sand and seaweed, but they were later pitted in the ground in large excavations. Arthur Nickerson said that, back in the 1920s, farmers "would spend the month of September back and forth

from the beach with a horse and cart carting seaweed and stockpiling it in the fields."

Even when he resumed turnip farming during the 1980s, Nickerson would bring back mounds of seaweed. He'd dig pits about two feet deep and toss in the loose turnips not yet gone to market, piling six to eight inches of seaweed over the top to insulate them. "The turnips in the ground like that will keep nice and brittle. They won't soften up," explaining that a turnip left in the house would go bad quickly.

Turnips also happened to be front and center during a 1938 Halloween prank. Arthur Benner, one of Eastham's largest farmers, had a truckload of turnips taken from his farm. According to the November 1, 1938 edition of the *Boston Globe*, Benner "was literally 'nailed' up in his own house while the turnips were being removed from a garage. He…found every door and window nailed with spikes." Neighbors had to free Benner with crowbars. The incident was described as "what might have become the town's first crime case in three years." The turnips were returned the next day.

Every so often, illness could play a factor in a farmer's harvest, so neighbors would rally to help out in what became known as the Eastham Turnip Pull. In October 1951, Harry W. Collins, who, with Raymond Brackett was one of the town's prominent turnip farmers, was "seized with illness" just before the harvest season and had been in the hospital for weeks. He would not live to see the end of the year.

On November 4, 1951, more than fifty volunteers ranging in age from ten to seventy-three gathered at the Collins farm on Bridge Road to harvest his crop. The *Cape Codder* reported:

> *A large portion of the top quality white turnips, a strain developed by Mr. Collins from seeds raised on his own farm, were turned back into the earth in pits covered with thatch and earth to await the day when they will be shipped to markets in Boston and Providence. Several orders, including one for 200 bushels, were shipped immediately.*

The idea for the Turnip Pull originated with the Eastham Grange, and the Fraternal Lodge, IOOF, joined in. Collins was a member of both organizations. Volunteers from the lodge were organized by Richmond Blake, former Noble Grand, and Grange member Maurice Wiley, chairman of the board of selectmen and a turnip grower himself, led the volunteers from the Grange. Members of the Eastham Explorer Scouts and the Orleans Sea Scouts, led by Moncrieff M. Cochran and Stanley Boynton, also pitched

This page: Local farmers banded together for an Eastham Turnip Pull to benefit George Nickerson in 1928. *Eastham Historical Society.*

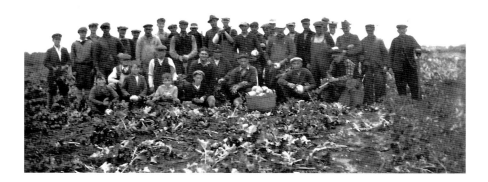

in. Women from the Eastham Grange served quahog chowder, apple pie and coffee to the volunteers at Eastham Town Hall for lunch.

Odd Fellow leaders recalled that in its earlier history, much of its attention was devoted to helping farmers in distress. Several years earlier, George Nickerson, one of the volunteers for the 1951 Turnip Pull, had been stricken with appendicitis, and the community rallied in similar fashion.

A Brief History of Eastham

As tourism began to take over Eastham during the 1950s, there were fewer and fewer farmers. Arthur Nickerson retired from his Route 6 automobile service station in 1980 and resumed his role as a turnip farmer. He got some turnip seed from Raymond Brackett, whose family owned a forty-eight-acre turnip and asparagus farm near the corner of Route 6 and Brackett Road. Nickerson and Joe King tilled, planted and tended ninety rows—each three hundred feet long—of plants, and these turnips were always in demand at local stores. He shipped them as far away as Alaska and Florida, and Colonial Williamsburg ordered several fifty-five-pound bushels for a special event. He once grew a turnip that tipped the scales at eighteen pounds, with several more weighing in just under that.

For many years, the Eastham Turnip was a mainstay at holiday dinner tables. "It was always the star accompaniment to our Thanksgiving turkey," Don Sparrow wrote in his book *A Cape Cod Native Returns*. "The rutabaga or yellow turnip had no place on our holiday table; we had to serve the white, Eastham variety."

Arthur Nickerson, who came to be known as the "Eastham Turnip Man," died at his Aspinet Road home in Eastham in 2008, at the age of ninety-three. A handful of local farmers, including Nickerson's family, have carried on the tradition of raising the Eastham turnip, and an annual harvest celebration, the Eastham Turnip Festival, has been held during the weekend prior to Thanksgiving since 2004 at Nauset Regional High School in North Eastham. However, the agricultural heyday of Eastham, as described by the *Sandwich Observer* in 1911, is no more: "[Eastham] is the greatest asparagus growing locality in southeastern Massachusetts, poultry raising is carried on extensively, good fishing, plenty of clams, quahaugs, oysters and the famous Eastham white turnips, so the citizens are a happy and contented community."

3

The Windmill

Eastham's Landmark

The road to the bay leads off at town hall, passing an old windmill which still has its grinding machinery in place. I entered it once, long ago, to see the dusty chutes, the empty bins, and the stones in their cheese-box cases of ancient and mellow wood. Locust trees enclose it, and song sparrows perch on the arms that have not turned for years.
—Henry Beston, The Outermost House, *1928*

In a town filled with historic landmarks, there may not be a more recognized site in Eastham than the famous windmill on the town green. Ask for directions anywhere in town, and the reply back usually begins with "OK, well, you know where the windmill is…"

The smock-type windmill dates to 1680, when millwright Thomas Paine, one of the most accomplished windmill builders on the Cape, constructed it in Plymouth before it was moved to Truro and then Eastham. "No one could build a windmill as taut and trim as Tom Paine," wrote Shubah Rich in *The History of Truro*.

"The curious thing is that while Thomas Paine built the mill in Plymouth, he was from Eastham, the mill eventually wound up in Eastham, and the last man to own the mill and run it as a business was a man named Thomas Paine, a descendant," said longtime Eastham miller Jim Owens in a 1981 interview for the Eastham Historical Society. Even the first wedding held inside the mill involved a Paine descendant; in 1981, she and her party journeyed from Boston to Eastham to hold the ceremony and went back to Boston for the reception.

According to the Eastham Public Library's "Eastham Land Records, 1650–1745," twenty-three-year-old Thomas Paine arrived in Plymouth Colony from England in 1635. In Eastham, he served in several town positions and owned horses and cattle, but the construction of windmills and tide mills was his business. In 1680, he built the windmill that would later grace Eastham's town green in Plymouth. In *Nauset on Cape Cod*, Alice Lowe noted that he later built windmills in Barnstable, Yarmouth and Truro. Paine and many of his family members are buried in unmarked graves at the Cove Burying Ground in Eastham.

According to Lowe, Nicholas Paine and Lieutenant Joshua Bangs built another mill in 1703 due to the amount of corn crops produced there: "Eastham was considered in 1760 the most important township in Barnstable County." In 1844, Enoch Pratt wrote that Eastham "was the only Cape town…raising enough grain for its own consumption as well as much for export."

The mill was sold to people in the Truro Highlands in 1780, according to Owens. It was taken apart, stacked on a raft and floated across the bay from Plymouth to Truro. After being there for thirteen years, it was put up for sale again, probably because the miller died and the family didn't want to run it.

Seth Knowles of Eastham bought the mill in 1793 and took it apart a second time, hauling it overland by oxcart from Truro to Eastham, where it was placed on a hill near Salt Pond. Fifteen years later, the property was sold, forcing the mill to be moved to its present location. The mill was jacked up on rollers, and oxen dragged the whole building in one piece.

After the move to Eastham, Lowe noted that the mill "was in such constant use, the miller was considered indispensable, therefore was not required to perform military service or to fill any town office." Flour was hard to keep, and there was no refrigeration in those days, so "that's why so many communities had a mill of some kind in the community," Owens said. "The miller would be a highly-prized category. You'd want a miller in your community, so that there would be some place very handy that you go and get fresh flour all the time."

Millers often used their children "for 'go-fers' for help to do this and to do that," Owens noted. "A good miller was known by the quality of the meal that he produced. If he produced good, finely ground meal of an even consistency, clean and with no grit, he was a good miller. And if didn't cheat on his charges, he was an honest miller."

There was also different ways millers kept track of their meal, according to Owens:

One was to rub it between thumb and forefinger to feel...if it's too coarse, and doing that for years and years and years often gave the miller a broad flat thumb and they used to call that a "miller's thumb." Some people are born with it, and years ago they would say that if you were born with a very flat, wide thumb, they'd say, "Oh, there must have been a miller in your family." They used to believe that you could inherit acquired characteristics. "Don't do that, your kids will all grow up cross-eyed!"

If stones run too hot, they produce a lot of heat, and if they run too hot, they scorch the meal, and that's no good. It makes the muffins taste funny. If the stone gets out of balance and strikes the bed stone, you get grit in the meal, and you shouldn't. Good stone-ground flour doesn't have any grit in it. And the miller could tell both of those things by smell. So he would constantly put his nose up close and smell it, and that's why they used to say "a good miller always kept his nose to the grindstone." And now you where that came from.

At the Eastham Windmill, "They ground corn most of the time and rye some of the time," Owens said. "They never ground wheat, because they didn't grow it here. It was too damp here. Some people occasionally grew it, but it was a gamble. Rye will do well in a damp environment. It's quite the opposite growing conditions of wheat."

The windmill wasn't the only one of its kind in Eastham. According to Frederika A. Burrows's *Windmills on Cape Cod and the Islands*, Eastham had four of the peninsula's thirty-nine windmills. *Pratt's History of Eastham* noted that a tide mill was located at the Salt Pond. Another was Horton's Mill near Sunken Meadow in North Eastham, but "that was taken down before the Civil War to avoid the payment of taxes, and they used the lumber for something else," Owens noted. It's believed that there may have been one on Nauset Road, according to Owens, but he's never been able to locate a record of it.

Thomas K. Paine was the last full-time miller, taking up the work after retiring as keeper of Billingsgate Light, located on an island in Cape Cod Bay, to the west of Wellfleet, on June 30, 1884. After Paine's death, his apprentice, John Fulcher Jr., filled in, until the mill was closed in 1895. "By that time people wanted white flour for breads which they got by train," wrote Steve Silva in a 1987 article about Owens and the windmill for the *Eastham Oracle*. "Transportation was the death knell for mills."

A local group known as the Village Improvement Society purchased the windmill in 1897 and planned to convert it into a library. Eventually,

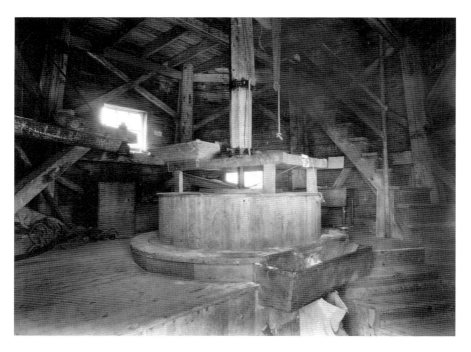

The interior of the Eastham Windmill. *Library of Congress.*

the library took shape a few hundred yards to the west on Samoset Road. According to Owens, the Village Improvement Society used the windmill for fundraising events and would sell cherrystone clams for twenty-five cents a bushel.

Outside of those activities, the windmill stayed relatively quiet for the next four decades, although it did have its share of visitors. In his book *The Outermost House*, Henry Beston wrote in the chapter "An Island Stroll in Spring" of how he went inside the mill a few years before his "Year on the Great Beach." Then there was Don Sparrow, the longtime Eastham historian and author of the book *Growing Up on Cape Cod*, who was one of the members of the short-lived Windmill Literary Society during the 1930s. Sparrow wrote that the mill "had a rich, musty, grainy aroma mixed with the scent of oak timbers," and that his brother, Fenton, was exploring around the mill's equipment:

> [Fenton] *hit his head on the flooring above, and noticed a trap door. He climbed through the opening and everyone else followed. A small window provided light and we could also observe the outside word from our 30-foot aerie without danger of detention. It made an ideal secret meeting place, the perfect clubhouse.*

The boys collected soda bottles and exchanged them for candy bars at Barton's store, with Mr. Goodbars being a particular favorite. On Saturday mornings, they would take out three books from the library—which was down the street—read them at the windmill while bingeing on candy bars and return them at day's end. However, only a few months later, the Village Improvement Society, realizing that a potential tourist attraction was gathering dust, bought the mill and transferred the ownership to the town. John Fulcher Jr. returned as miller and demonstrated the grinding. As Silva noted in the *Eastham Oracle*, "[S]ome adventurous children were known to grab on to the arms of the mill for a joy ride as Fulcher still ran the mill frequently at that time." John Higgins and Harold Cole followed Fulcher as millers, which had become more of a docent position. Higgins was a unique character; he produced windmill postcards with his picture on it and had the ability to "play two harmonicas at the same time, one with his mouth and one with his nose," according to Owens.

When Cole died in 1965, Freeman Hatch and Clarence "Jack" Webster ("no one knew him as Clarence," the *Cape Codder* reported in his obituary) were recruited, but not without some controversy. A town employee

A Brief History of Eastham

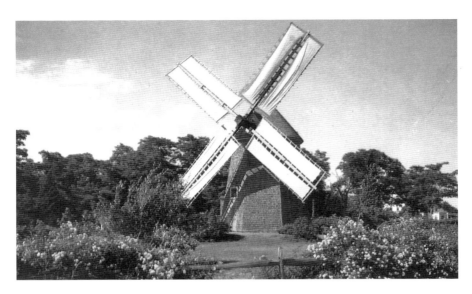

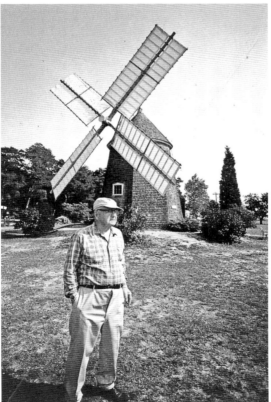

Above: The Eastham Windmill, complete with wind sails. It took a wind speed of twenty miles per hour to operate the mill. *Eastham Historical Society.*

Left: Freeman Hatch, one of Eastham's millers from 1965 to 1974. The appointments of Hatch and Jack Webster were not without controversy, as it took a state legislature override of a veto by Governor John Volpe to appoint the duo. *Eastham Historical Society.*

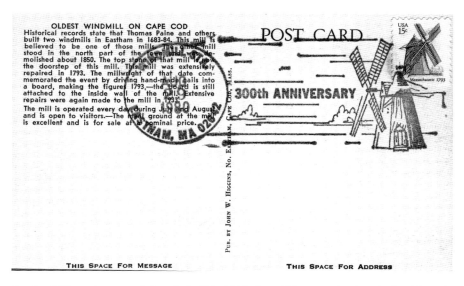

On the 300th anniversary of the windmill in 1980, the mill became the site of a legal branch of the U.S. Post Office. John Ullman, editor of the *Cape Codder*, was a stamp collector and arranged for the special designation of Windmill Station. This image shows the stamp and its own cancellation. *Jim Owens.*

questioned Eastham's right to retain any worker over the age of seventy, and the Massachusetts Bureau of Accounts agreed. According to the *Cape Codder*, "[A] very brief brouhaha ensued before the then head of the bureau agreed that they could be employed 'if it were found that no qualified person' was available, but only on an emergency basis." After the Massachusetts legislature approved the measure, Governor John Volpe vetoed it, but "the legislature was in a fit of pique with him about something else, so they overrode his veto and said 'We're going to do it anyway.' And it was done," Owens recalled. "The town got them hired, simply because the legislature was mad at the governor. Usually nobody benefits by those arguments, but in that instance, we did."

By 1974, Hatch had fallen victim to illness and couldn't do the job anymore, and Webster, eighty-six, was unable to handle the whole day by himself. Selectman Howard Quinn then approached Owens, an Eastham native, former commercial artist and longtime art teacher at Nauset Regional High School in Orleans, about the job. Owens eagerly accepted.

At this point, the windmill was in need of repairs, including the roof and wind shaft. The mill's arms were replaced by Ian Ellison, and new sails were purchased for the American bicentennial celebration in 1976. For the

bicentennial, there was a post office at the windmill because the mill's image was on a commemorative stamp of the postal service. Owens recalled in 2016 that the windmill was "open on Labor Day and we canceled, stamps on that holiday." On the 300th anniversary of the windmill in 1980, the mill became the site of a legal branch of the U.S. Post Office. John Ullman, editor of the *Cape Codder*, was a stamp collector and arranged for the special designation of Windmill Station.

In 1977, the town established Windmill Weekend, a festival held on the first weekend after Labor Day. During the 1979 Windmill Weekend, the ninety-one-year-old Webster was recognized for his work as a miller and received a pewter plate with a windmill motif at a special ceremony. That Monday, according to the *Cape Codder*, he informed the selectmen that things were slowing down and he was going to open the mill only on weekends. He died the next day.

4
THE ERA OF "THUMPERTOWN"

> *"Thumpertown Road" came by its name as a result of the old time revival meetings in the Camp Ground area. In their zeal of worship, the good folk of that day did a lot of hollering and an equal lot of "thumping" in their mass gatherings. Hence, Thumpertown.*
> —Cape Codder, *August 16, 1951*

During the period between 1838 and 1863, the fires of evangelism raged along the bay shore of Eastham. It was on ten acres of land known as Millennium Grove, or Thumpertown, located in the area of what is now known as Campground Beach, where the Camp Meeting Grove Corporation held its summer revival meetings, often by the light of the full moon.

"Large numbers gathered to hear preachers, sing hymns, study the Bible and share the joy and agony of penance," according to Marilyn Schofield and Roberta Cornish of the Eastham Historical Society. "Emotions often reached a high pitch." Tents were put up for the worshippers, while ministers stayed in a small frame house.

In 1841, the *Boston Transcript* described the meeting in Eastham as "the annual explosion of the concentrated spirit of Methodism…on the shores of Cape Cod."

South Wellfleet hosted the first meeting in 1819, according to Agnes Rothery's 1918 book, *Cape Cod Old and New*, followed by meetings in Truro and Provincetown before settling in Eastham, a place "that the history

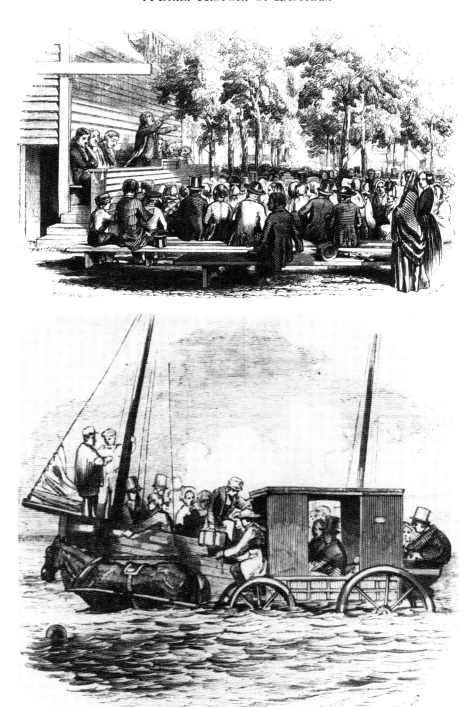

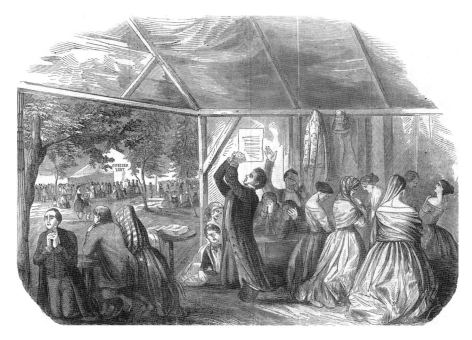

Above: One scene from an Eastham camp meeting at Millennium Grove. *Eastham Historical Society.*

Opposite, top: "Exhortation and preaching" at a camp meeting at Millennium Grove. *Eastham Historical Society.*

Opposite, bottom: According to Agnes Rothery in her 1918 book, *Cape Cod Old and New*, "One who decided to attend the camp meeting first had to drive to Barnstable; from there take a vessel to Eastham; row from the vessel to shallow water by a farm wagon; and then walk a mile through the sand to the Camp-Meeting Grounds." *Eastham Historical Society.*

of the Methodist Episcopal Church on Cape Cod really dates, and as we see the white-spired churches, dotting the scattered hamlets all through Barnstable County, we cannot help but be struck by the significance of the religion which ever since its inception has been unbrokenly characteristic of this region."

As Rothery noted, "One who decided to attend the camp meeting first had to drive to Barnstable; from there take a vessel to Eastham; row from the vessel to shallow water by a farm wagon; and then walk a mile through the sand to the Camp-Meeting Grounds." Life didn't improve much on arrival; participants sat on bare planks with no backs, and there was only one well on the premises.

Henry David Thoreau wrote in 1855, "There are sometimes one hundred and fifty ministers, and five thousand hearers, assembled." Where these people came from is up for debate; Cape historian James O'Connell maintained that the revivals attracted Cape Codders, while historian Ellen Weiss stated that the Eastham meetings were "beloved by Bostonians," who arrived by packet at the campground landing.

Many of the visitors from Boston made the trip for the preaching of the Reverend Edward T. Taylor, also known as "Father Taylor." "His chief place of camp-meeting life and joy was Eastham," wrote Gilbert Haven and Thomas Russell in 1873. Taylor was "famous for his dramatic and salty oratory and was the model for Father Mapple in Melville's *Moby Dick*," wrote William Lloyd Garrison.

Taylor, who went to sea at the age of seven and was captured by the British during the War of 1812, entered the New England Conference as a traveling preacher in 1819 and traveled the circuits on the South Shore and Cape Cod for the next ten years. The Seamen's Bethel in North Square, erected in 1833 by the Port Society of Boston, was a group formed by Methodists "to further the moral and religious welfare of sailors," according to Garrison.

The packet trip to Taylor's first meeting in Eastham was not a smooth one. Isaac Jenninson recalled to Haven and Russell that "some thirty or more members of the Methodist Church of Boston, with seven ministers," journeyed by packet to Wellfleet, but as the vessel passed Boston Light, a thunderstorm raged over the harbor. "It caused much confusion among the passengers; some shouting, some praying and crying for mercy. The lightning struck the mast; and the captain, standing near it, was stricken to the deck unhurt. No one was seriously injured."

Thoreau described Millennium Grove as "the most suitable, or rather unsuitable, for this purpose of any that I saw on the Cape. It is fenced, and the frames of the tents are, at all times, to be seen interspersed among the oaks. They have an oven and a pump, and keep all their kitchen utensils and tent coverings and furniture in a permanent building on the spot."

The revival meetings, however, were not without crooks or critics. In 1841, the *Boston Post* had this account from Eastham:

SHARPERS AT EASTHAM CAMP MEETING

On Saturday, at the Providence Railroad Depot, Constable Clapp arrested a couple of gambling tricksters, who have been operating at the Eastham Camp Meeting, with thimble-rigs, magic balls, false card cases. The tools

Henry David Thoreau described Millennium Grove as "the most suitable, or rather unsuitable, for this purpose of any that I saw on the Cape. It is fenced, and the frames of the tents are, at all times, to be seen interspersed among the oaks." *Eastham Historical Society.*

were found upon them, together with two watches, which they had tricked out of their victims, $27 in good money, a bad $50 spot, and an awful nasty looking second hand silk handkerchief. The complaint against them was made by one Alexander Mackenzie Campbell, whom they eased of a watch. They were lodged in jail.

Thoreau noted that he "saw the heaps of clam-shells left under the tables, where they had feasted in previous summers, and supposed, of course, that that was the work of the unconverted, or the backsliders and scoffers. It looked as if a camp-meeting must be a singular combination of a prayer-meeting and a picnic." Years later, a photograph of Millennium Grove,

A Brief History of Eastham

The campground at Millennium Grove, shown several years after the last camp meetings were held there. *Eastham Historical Society.*

tucked away safely in the archives of the Eastham Historical Society, was inscribed: "Millennium Grove, where more souls were made than saved."

However, it wasn't long before Thumpertown went through a conversion, going from a place for saving (or making) souls to a slaughterhouse. Gustavus and Nathaniel Swift opened a business on the bay shore during the winter of 1859–60 that would grow into one of the largest meatpackers in the country. In 1936, Samuel Nickerson recalled how he used to help the brothers herd pigs along Cape highways. After slaughtering, one brother would head to Wellfleet, the other to Brewster and Orleans, in horse-drawn wagons, to make deliveries. Gustavus Swift opened a meat market there in the winter of 1859–60, and in 1861, he married Anna Maria Higgins, who was a descendant of Richard Higgins, one of the seven original Purchasers of Eastham in 1644.

In 1861, Gustavus Swift moved to Cummaquid in Barnstable. Nathaniel Swift lived in a house just south of the windmill, which was built by Joshua Knowles in 1741. After the Swift brothers moved to Chicago to make their fortune, the house was sold to the Daley family in 1876. The Daley family donated the house to the Eastham Historical Society in 1974, and it is now operated as a museum.

5
The Eastham Railroad's Golden Age

It was a fine colorful era while it lasted. And lucky are those who can summon up a nostalgic and affectionate memory of the romantic old Iron Horse as it chugged into town.
—Backgrounds: Cape Cod's Golden Age of the Iron Horse,
Cape Cod Central Railroad Company

Prior to the years after the Civil War, there were two ways to travel to the outer reaches of Cape Cod: either by sea in one of the packet vessels that traveled to Boston and other points beyond or by stagecoach, which involved a long, bumpy ride over the peninsula's sandy roads.

In 1848, the Cape Cod Central Railroad (which eventually became the Old Colony Railroad in 1872) came to Sandwich, but it was nearly two more decades before the first train rolled into nearby Orleans on December 6, 1865. It was also just what many of the Eastham farmers needed to get their crops shipped off to Boston. According to Dianne Greaney of the Orleans Historical Society,

> It had been postponed because of the Civil War, because of the need for the materials. The toughest part was that they had thirty-six street crossings that they had to handle between Orleans and Hyannis, they had to build the Bass River Bridge, and had to deal with the change of elevation factor of sixty-eight feet between Brewster and Pleasant Bay. Those were all challenges they had to meet.

Orleans was the end of the line as of 1865, but it was later extended, under the supervision of Abijah Mayo, to Eastham and then Wellfleet by 1869 before ending up in Provincetown by 1873, when President Ulysses S. Grant visited the Cape tip for the celebration. Shortly after this, bigger and faster trains were brought in, such as the *Dude* train. According to *Cape Cod Magazine*, in 1916, Harry Meyers, who named the train, was its first conductor. By 1877, fourteen out of fifteen towns had been connected by the railroad. As Dianne Greaney noted:

> *When it terminated at Orleans, they had a roundtable that they would pull the engine off on a separate siding, and then the train would go on to this turntable. It could be turned around by one or two people, it was so well-balanced, and the engine would be going the other way, and would back up on to that siding, and attach the cars. When they made the extension, they moved that portable turntable up to the next stop.*

Bernard Collins, who was born in 1896, recalled in a 1977 interview with Tales of Cape Cod that the trains just after the turn of the century had four or five passenger and freight cars together and ran on "a single track, so

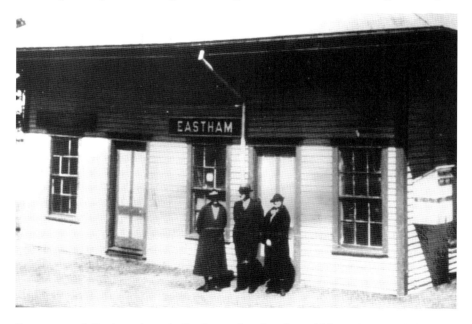

Passengers wait for the train at the Eastham railroad station, which was located off Samoset Road. The station closed in 1940. *Eastham Historical Society.*

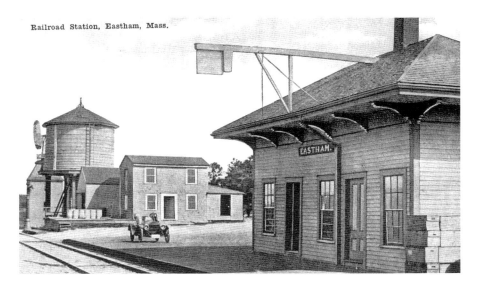

The first Eastham railroad station was located just west of Chapel in the Pines, the Eastham Public Library and the Eastham Windmill. The Cape Cod Bicycle Trail has since replaced the railroad tracks. *Eastham Historical Society.*

therefore they had to stagger things so there's be no smashups." In *Nauset on Cape Cod,* Alice Lowe noted that the early wood-burning locomotives and train cars were all painted yellow.

The passenger trains "would have two general passenger cars—one car that would carry mail and baggage, and then a smoking car for men only," Greaney noted. The well-dressed men on board were often asked to help load the wood (for fuel) on to the train. The stations had areas to protect the passengers from the elements, "but they found that all the smoke and particulates were worse than any of the rain that could get on the ladies' dresses," according to Greaney.

Bernard Collins's son, Kenelm Collins, recalled at a 1997 Eastham Historical Society event that he lived in South Eastham during his youth in the late 1930s and would often go out on the Lamont Smith property (now home to the Wildcare facility) to watch the train go by. He would wave at the passing train, and the engineer would blow the whistle back. One day, the engineer spotted the young Collins at the Orleans station and said, "Hey, Red, aren't you that kid that waves at us alongside the track? Come aboard, let me show you around." Collins, eleven at the time, remembered that "to climb up into the cab of a steam engine was fantastic. The gauges, the throttle, brakes, whistle, the open firebox—I could see the coal burning."

A Brief History of Eastham

Traveling at about twenty miles per hour, "You could hop aboard the train in Boston at 9:00 a.m. on any weekday, and be in Orleans by 12:13 p.m. and in Provincetown by 1:05 p.m." In 1891, the Cape Cod Central Railroad Company proclaimed in *Backgrounds: Cape Cod's Golden Age of the Iron Horse*, "This is excellent time, considering the train made 27 stops before it arrived at the Cape tip."

The tracks ran parallel to Bridge Road and eventually led to the first station in Eastham, which was located off Samoset Road. During the late nineteenth and early twentieth centuries, it was no secret when the train arrived, especially to landlords such as H.M. Sullivan, who lived in a Gothic Revival Victorian house across from the Salt Pond. Gazing over the treeless, wide-open landscape, Sullivan could see clear over to the train station from his house, which also functioned as an inn. "It was said that the owner knew when potential business was imminent, as the view from the house to the old depot was unimpeded, thus he could see his old tenants as they got off the train," according to a Massachusetts Historical Commission file on the house.

While the first Eastham station had its share of activity, the North Eastham depot "was the social center of town," according to C. Winfield Knowles in a letter to the *Cape Codder*. Knowles noted that the "Night Train," which arrived at 6:00 p.m., was a highlight of the day. "We never met the train because we thought any traveler would be on it, we met it because it

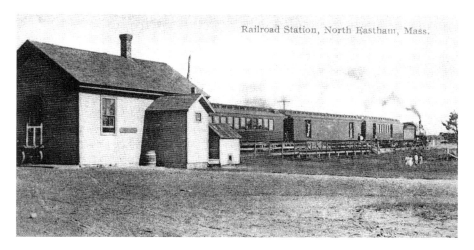

The North Eastham station was the second railroad stop in Eastham. The station closed in 1935. *Eastham Historical Society.*

was the stylish thing to do even though it meant a sizable walk," Knowles wrote. Bernard Collins noted: "It used to be quite the thing, when I was a young fellow, to go down there. I'd walk two and a half miles to see the train come in." Knowles added that the daily mailbag was usually the most important delivery from the train and that "competition was keen as to who would take it to the post office."

Eastham residents also found other ways to benefit from the railroad. According to Lowe, many locals bought shares of Old Colony stock and would get free tickets to Boston on stockholders' day, an annual event held two days before Thanksgiving. People would plan their holiday shopping trips around this arrangement.

However, just as the railroad took over for the packets and stagecoaches, the automobile and the modernization of roads began to push the trains off the Cape Cod landscape. The North Eastham station was closed in 1935, and the Eastham depot followed suit in December 1940. By 1967, all remnants of the old railroad had been removed.

Construction of the modernized Route 6 was completed in the early 1960s. Today, the railroad's path from South Dennis to Lecount Hollow in Wellfleet serves another purpose as a twenty-two-mile bicycle trail, also passing through Harwich, Brewster, Orleans and Eastham. Relics from the railroad days can still be spotted along the path. As the Orleans Historical Society notes in its *150 Years: Rail to Trail* brochure: "Defiantly, the very cars and trucks that doomed the railroad are banned from this historic route."

6

Nauset Light

The "Big Star" of Eastham

Facing north, the beam of Nauset becomes part of the dune night. As I walk toward it, I see the lantern, now as a star of light which waxes and wanes three mathematical times, now as a lovely pale flare of light behind the rounded summits of the dunes.
—Henry Beston, The Outermost House

In the years prior to 1838, there were only two lighthouse sites along the shore of outer Cape Cod: Highland Light in Truro, built in 1797, and the twin lights of Chatham, which followed in 1808.

In 1838, new beacons of light emerged on the dark cliffs of North Eastham: the Three Sisters of Nauset. By 1923, it had become what is now the present-day Nauset Light, a landmark that "everyone has a soft spot in their heart" for, as Hawkins Conrad, president of the Nauset Light Preservation Society, told the *Cape Codder* newspaper of Orleans, Massachusetts, in 1996.

There was "one Eastham boy who, in babyhood, felt the night-time comfort of the light sent out to guard the vessels on the deep," wrote Alice A. Lowe in her 1968 book, *Nauset on Cape Cod*, for the Eastham Historical Society. "[He] used to go to his window at bedtime to say 'Good Night' to the 'Big Star.'"

Today, Nauset Light is one of the most popular tourist destinations on Cape Cod, a favorite of artists and photographers. The image of the iconic lighthouse can be found on bags of Cape Cod Potato Chips and the special-edition Cape Cod license plates issued by the Massachusetts Department of Motor Vehicles.

A Brief History of Eastham

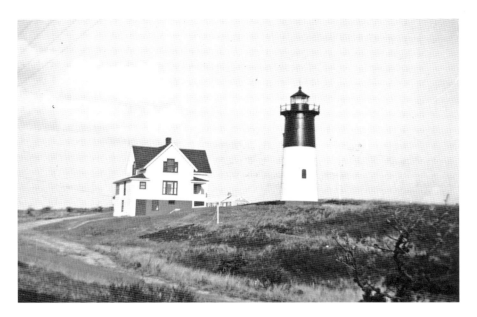

Nauset Light, as seen in 1951. Although the tower was moved from Chatham to the Eastham bluff in 1923, the top half wasn't painted until 1940. *Eastham Historical Society.*

When the first incarnation of Eastham's outer beach beacons was unveiled in 1838, the Three Sisters weren't very appealing to visitors or Eastham residents. As Fay Shook recalled in an oral history interview with the Eastham Historical Society in 1991, "The sailors thought they looked like three ladies in white dresses with black bonnets."

Edward Rowe Snow noted in his 1945 book, *Famous Lighthouses of New England*, that inspector I.W.P. Lewis called the three light towers a "curious trio of lighthouses" and noted their shoddy construction.

Snow added that Ralph Waldo Emerson visited Michael Collins, the first keeper at Nauset Light. Emerson said, "Collins the keeper told us he found resistance to the project of building a lighthouse on this coast, as it would injure the wrecking business."

Congress established six lighthouse districts in 1838, and the shores of Cape Cod were included in the second district. To the north, Highland Light (also known as Cape Cod Light) in Truro provided one light, while the Chatham Light Station to the south had two. Nauset would have the "curious trio," which was still an improvement over the previous situation—total darkness along the Eastham coast. Shook explained what life at sea was like in the 1830s: "Lighthouses were very friendly because

On the Outer Beach of Cape Cod

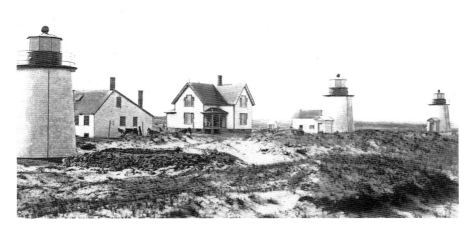

The Three Sisters lighthouses of Nauset are pictured on this undated postcard published by A.W. Hideout of South Wellfleet, Massachusetts. *Eastham Historical Society.*

they literally said 'Beware' as they blinked. They would say, 'beware because you are close to shore. Be careful in my waters.' There is a large sandbar off Nauset Shore. Many a boat was wrecked off that that sandbar before there was a Nauset Lighthouse."

When Henry David Thoreau visited Eastham in 1857, he noted in his book, *Cape Cod*, the Three Sisters "were so many that they might be distinguished from others; but this seemed a shiftless and costly way of accomplishing that object."

Mary Daubenspeck vanRoden, whose 1995 book, *Nauset Light: A Personal History*, chronicled her years as a keeper at the light, noted that the quality of lighthouse construction was questionable between 1820 and 1852. Trained army inspectors oversaw construction, but much of the work was done on the local level, rendering the inspectors' influence less effective.

In June and July 1838, a crew of eleven men, led by Captain Winslow Lewis of Wellfleet, took thirty-eight days to build four washed brick structures: three towers, spaced 150 feet apart, and a keeper's house. The project cost $7,000, coming in $3,000 under budget.

According to a retrospective article in the March 4, 1954 edition of the *Provincetown Advocate*, the Three Sisters of Nauset "were the idea, the brainstorm, of old Captain John 'Mad Jack' Percival, who chose and staked out the site."

A Brief History of Eastham

David Bryant, an overseer for George Bancroft, the superintendent of lighthouses along the Massachusetts coast, was less than pleased with the results. He noted that the lights weren't even located on the spots staked out by Percival and "they were built far too quickly, and carelessly." Completing the project over thirty-eight consecutive days also meant that Sunday was a workday, according to the *Advocate*: "Apparently, the four masons, two carpenters, three laborers, and a cook worked on Sundays there on the Cape, where such desecration of the Sabbath was still a sin. For their sin God was quick with punishment. On the job a mason and a carpenter took sick with smallpox."

Bryant's statements, however, were not well received by Stephen Pleasanton, director of the federal lighthouse service. According to the *Advocate*, Pleasanton threatened Bryant with legal action, and the problems went unresolved.

According to vanRoden, it was in 1842 that another inspector found that the towers were built without foundations or footings. Due to the usage of bad lime in the construction, leakage became a problem, as there was no bonding between the bricks. It wasn't until 1856 that the outdated reflector systems, invented by Winslow Lewis, were replaced by Fresnel lenses and valve lamps, improving the efficiency of the light. However, the structural

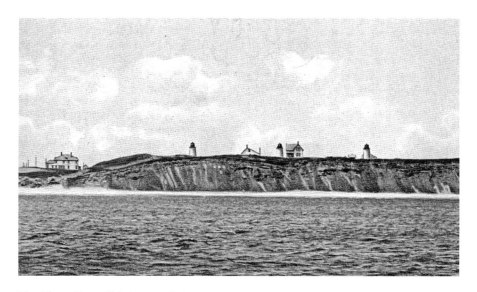

The Three Sisters lighthouses of Nauset, along with the French Cable Station, as seen from the Atlantic Ocean on this undated postcard, originally published by the Hugh C. Leighton Company of Portland, Maine. *Eastham Historical Society.*

issues continued. In March 1968, S. Stewart Brooks shared some entries from an 1874 keeper's log in his "Orleans Scenes" column in the *Cape Codder*:

> *January 2: 1874:* "*Stormy, rain all day. Towers leaking bad.*"
> *January 8:* [almost word for word as January 2]
> *January 25:* "*Heavy gale and rain. Towers all sand inside and outside.*"
> *January 26:* "*Better weather today. Clean out the sand from towers and clean plate glass.*"
> *February 14:* "*Raining this morning. All the towers leaking bad. Everything all wet and in poor order.*"

The present-day keeper's house replaced the original structure in 1875. Due to erosion, new light towers, standing twenty-two feet high, were constructed. The old structures were allowed to topple off the cliff and on to the beach.

It wasn't long before the Three Sisters had a neighbor on the bluff. In November 1879, the French Telegraph Cable Company, or Cie Française des Cables Telegraphiques, linking the United States to Brest, France, moved from nearby Duxbury, Massachusetts, to North Eastham, where a two-story building was constructed. According to Alice Lowe, the steamer *Faraday* brought the cable in from St. Pierre, Nova Scotia, and "the beach was thronged with townspeople waiting to see it land." Two days later, the cable was connected, and the first message was received in the basement of the keeper's house before the cable station's construction was completed. The cable connection of the two countries was "that simple and lacking in ceremony," reported the *Cape Codder* in its September 12, 1946 edition.

Adin Gill, whose father, Nathan, was the keeper at the Three Sisters in 1879, was nine years old when the French Cable Station arrived. He recalled that "the cable was tested in the dwelling part of the lighthouse." He also told the *Cape Codder*: "When I was a kid I used to go to the cable house by the Lights and watch 'em. There would be light flashes coming from an opening at the end of the cable. A man would read letters out of the flashes. A lot of the communications came in code. Later on, there was a tape-message system."

However, the North Eastham location proved to be inaccessible, and the French Cable Station was moved to a location on the Town Cove in Orleans in 1891. It was at the Orleans site that the news of Charles Lindbergh's airplane crossing the Atlantic was first received in 1927. The old French

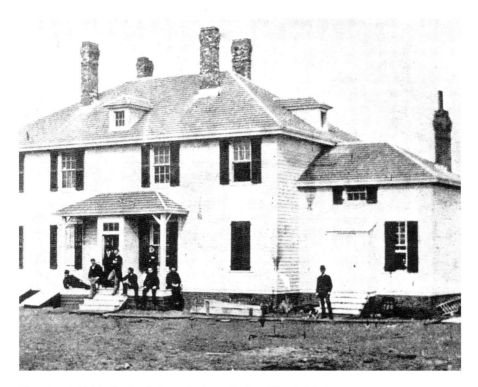

The French Cable Station in its early days. *Eastham Historical Society.*

cable site at Nauset became a summer hotel, but it burned down in 1901, according to the May 6, 1901 edition of the *Barnstable Patriot*.

A brick oil house, measuring eleven feet by nine feet, four inches, was constructed in 1892. It was capable of storing 450 five-gallon tins of oil, which was enough fuel for thirteen months.

By 1911, the Three Sisters would soon become one sister on the cliff. A mere eight yards separated the cliff and beacons, and the north and south lights were decommissioned. The central tower was moved back and linked by a covered walkway to the keeper's house.

In 1918, the decommissioned towers were sold to Mr. and Mrs. B.J. Cummings for $3.50 each at a public auction. What led to the sale was an even more interesting transaction, as Shook noted in her oral history with the Eastham Historical Society: Mr. and Mrs. Cummings owned an automobile and drove to Nauset from their home in North Attleboro, Massachusetts. While at the beach, a man walked up and expressed his admiration for their automobile. He asked if they would consider a trade of the car for the house,

On the Outer Beach of Cape Cod

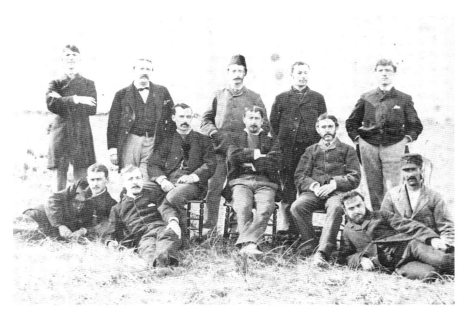

The crew of the Eastham French Cable Station, from 1881. Pictured here are, from left to right (*first row*): C. Albert Ronne, Mr. Self, A.F. "Fred" Toovey, Superintendent Charles Marsily, H.G. Wilson, George S. Hall and Nathan A. Gill; (*second row*): Mr. Quinn, James D.B. Stuart, George Williams, Everett G. Dill and John H. Smart. *Eastham Historical Society.*

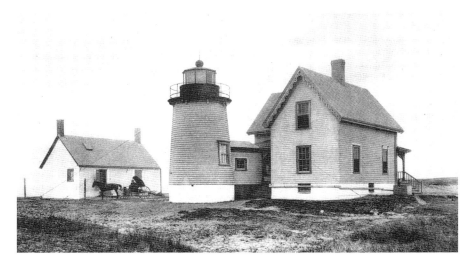

The central beacon of the Three Sisters is pictured in this undated photograph. *Eastham Historical Society.*

stable and land that he owned. After inspecting the property, he asked about a spare tire for the car, and they replied that they had one at home. For the spare tire, he offered more acreage down the road. At the expense of their car, the Cummings received the house, the stable and twenty acres of land.

The Cummings then followed with the purchase of the former Sisters and, minus the lanterns and tower tops, moved them to their property. They put a tower at each end of the house and used them as sleeping quarters. "They made marvelous bedrooms," Shook recalled. "They were round and I used to spend a lot of time in those towers."

In 1924, the last sister was bought at public auction by Albert and Mary Hall of Eastham for fifty cents. They used it as a summer cottage they called the Beacon before the Cape Cod National Seashore acquired it in 1975. The park eventually reunited it with the other two sisters near the Cummings site on Cable Road.

Through the Three Sisters years, the keepers included Michael Collins, Peter Higgins, Nathan Gill, Stephen Lewis, Thomas Kelley and James Yates. John Poyner and George Herbolt were the keepers from 1919 to 1932 and oversaw the transition of a new era in the history of Nauset Light.

On June 18, 1923, with erosion once again posing a threat, the present-day tower was moved from Chatham, replacing the last sister. The replacement beacon, an ironclad brick-lined structure, was one of

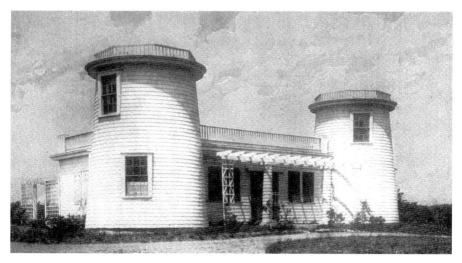

Two of the Three Sisters towers were sold to Mr. and Mrs. B.J. Cummings of North Attleboro, Massachusetts, in 1918. Minus the lanterns and tower tops, the structures were placed at the ends of a cabin to serve as bedrooms. *Eastham Historical Society.*

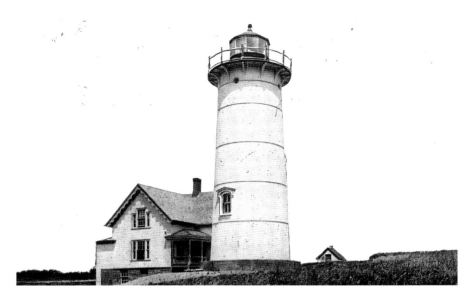

The Nauset Light prior to 1940, when the red stripe was painted on the upper portion of the lighthouse. *Eastham Historical Society.*

the twins at the Chatham Light station, built in 1877. The first Chatham lights, made of wood, were constructed in 1808. The tower was painted white when it arrived in Eastham; it wasn't until 1940 that it was painted red to "better serve as a daymark," according to vanRoden.

How the light got from Chatham to Eastham is a subject of some dispute. In the November 19, 1996 edition of the *Cape Codder* newspaper, Edward F. Maroney noted that there was little media coverage of the move and one of the Chatham towers was "floated by barge" to the new site. "In those days, however, the word 'barge' referred to any long, flat platform pulled by horses or oxen. One woman said she recalls 'going to school by barge,'" Maroney wrote.

Maroney pointed to a 1924 report from the late historian Grace Hardy that was read to the Chatham Historical Society. "On May 15, 1923, one light was discarded, the lantern moved to the lighthouse at Nauset and the North Tower torn down," she noted. "This would seem to indicate that the lighthouse building itself was demolished. No other evidence has been located to support this view."

Maroney's article also noted that Shirley Sabin, a longtime volunteer for both the Cape Cod National Seashore and the Nauset Light Preservation Society, remembered seeing the lighthouse—cut up into sections—leaving

Chatham, probably along Orleans Road, for Eastham. Sabin said that local historian Eleanor Henderson recalled seeing it pass by her house. The motive power was "about 20 oxen [pulling] a barge with wheels."

From 1925 through 1928, the lighthouse was a landmark for Henry Beston during his "Year on the Beach," living in a twenty- by sixteen-foot cabin on the dunes a few miles to the south.

During his stint as keeper from 1932 to 1938, Allison G. Haskins renovated the lighthouse into "a showplace station," which won the district pennant for the sophomore keeper, according to the November 19, 1996 edition of the *Cape Codder*. "He was always painting and polishing the brass, and we couldn't touch the painted part of the door, just the doorknob," his daughter, Barbara, recalled.

The light also became an annual stop for the "Flying Santa," the writer and historian Edward Rowe Snow, during his annual Christmas visits by helicopter to lighthouses on the New England coast. During the 1930s, keeper Fred S. Viedler and his family spelled out the message "Santa Hello" for Snow in the area in back of the lighthouse. "The greeting was constructed by placing scrub pine branches in the form of letters," Snow wrote in his 1945 book, *Famous Lighthouses of New England*. "Keeper Viedler, his son and his wife had worked all morning long arranging the spelling so that we could read the words from the air."

Eugene Coleman replaced Viedler as keeper in 1942, and he would be the last one to hold the post. During this time, Fay Shook spent most of her time at the light:

> *It still didn't have electricity at that point. How did we make the light go round? There was a weight, which was attached to a long cable. You would wind the weight up until it got to the top. Then there was a little button. When the lighthouse keeper wanted the light to be activated and go round, he would release the button and the weight would start moving down. That is how the lighthouse showed three blinks.*

In 1952, a motorized electronic beacon replaced the Fresnel lens, ending the need for a keeper. The property was then divided, with the Coast Guard retaining ownership of the light and ten feet of land around it. The remaining property was purchased by a Boston judge, William Shaw McCallum, who ended up being an absentee owner. U.S. Air Force colonel Lucian Rowell and his wife, Miriam, bought the property in 1957, but they didn't move in until their retirement ten years later.

On the Outer Beach of Cape Cod

The Rowells made many improvements to the property between 1967 and 1982, when Miriam Rowell, no longer able to care for it, found a suitable buyer in Mary Daubenspeck vanRoden. One of those projects was a patio made of bricks from the old Three Sisters towers, which had been recovered from the beach. Rowell also had the house re-shingled during the 1970s, but that project—and the rest of the property—took quite a beating during the storm known as the Blizzard of '78.

Miriam Rowell wintered in London and enlisted Jack Clarke, a ranger at the Cape Cod National Seashore's Salt Pond Visitors Center, who lived around the corner, to stay at the keeper's house while she was away.

When Clarke returned home on the night of February 6, 1978, he hardly expected a storm of epic proportions. While the rest of eastern Massachusetts and southern New England was buried under more than three feet of snow, the outer reaches of Cape Cod were in the crosshairs of an astronomically high tide, combined with a storm surge and hurricane-force winds. The storm changed the landscape of the Outer Cape, particularly Eastham, forever.

"She had just had new shingles put on the house," Clarke recalled in a 2008 interview for the Henry Beston Society. "That night, the shingles just blew off the house, and water poured into the second floor, all the way down through the stairs. We had a major flood."

Clarke recalled that the Nauset Light went out. "You could see blue flashes all the way down from Nauset Light to Coast Guard Beach as various electric units on the telephone poles blew out."

Clarke settled in for the night in a big brass bed, but a restful sleep wasn't in the cards. "I was not only afraid of some really serious destruction of the house from the wind; I thought the whole window and frame was going to blow in," he recalled. "So I just pulled the covers over me and it was like there was a ghost in the room. The paperback books flew all around the room and fine, silt sand just blew in the window, and the back of the room had a little sand dune at the bottom of the floor."

Unlike many of the cottages on Coast Guard Beach to the south, Nauset Light survived the Blizzard of '78, but as the 1990s approached, the edge of the cliff was getting closer to the light. In sixty years, erosion had claimed close to two hundred feet of land, and another move would be necessary.

This time, however, there was an obstruction to saving the light. In September 1993, the Coast Guard published an official notice to mariners seeking comment on a proposal to decommission Nauset Light. On October

1, editorials and articles were published in the local newspapers, alerting the public about the commission's proposal.

Later that year, a public meeting of fifteen people, which turned out to be the initial gathering of the nonprofit Nauset Light Preservation Society, was held at the Chapel in the Pines on Samoset Road.

In an effort to find another home for the light, architect Conrad Nobili offered up two acres of his own land near Coast Guard Beach in a letter to the *Cape Codder*:

> *The two items that have put Eastham in the history books and on the maps are the Coast Guard station and Nauset Light. One sits smoldering, sadly neglected, on its stately bluff, and the other is about to be shut off and let fall into the sea. All of our lives have been made memorable because of their existence, their presence, and their histories. We have something to point to and it feels good. It enhances us all. Let us not let them go.*
>
> *I have several unused acres on the bluff at Coast Guard Beach. My hearth is at 65 feet above mean high water and those acres crest to 100 feet above mean high water—high up enough and far back enough to last one century. I would gladly donate them as a site for Nauset Light from whence it could sit in proud composition with its sister, the Coast Guard Station.*

Nobili's gesture didn't go far, as the land was deemed unsuitable for the move. After the 1993 ruling, funding wasn't available to move the light, and the notion was to break it down and restore it as a non-functioning shell when money eventually became available.

The Nauset Light Preservation Society, which grew rapidly into a membership of more than eight hundred in forty different states and around the world, swept into action. Led by Joan Lee and Pam Nobili, the nonprofit group collected $130,000 through fundraisers, private donations, membership dues and merchandise sales, enabling the light to be moved.

On November 15, 1996, workers from the International Chimney Corporation of Buffalo, New York, assisted by Expert House Movers of Sharptown, Maryland, undertook the task of moving the tower across the road to its present location. According to the *Cape Codder*, the original foundation was cut away from the footings, "using three-foot in diameter diamond-tipped circular saw blades." Through a complex system of steel girders, hydraulic jacks, large-wheeled dollies and a truck, the light reached its destination across the road, undamaged, in ninety minutes.

"In an age where computers are given the ultimate control in deciding what can be accomplished, the move of Nauset Light was done the old-fashioned way, with muscle, experience, and basic no-frills engineering," reporter Doug Fraser wrote in the *Cape Codder*.

Today, the Cape Cod National Seashore owns the property, while the Nauset Light Preservation Society gives tours, provides funding and maintains it, allowing the beacon's beam to scan over the landscape, sea and sky of the Outer Cape.

In November 1996, Mary Daubenspeck vanRoden told Fraser that she "found much more than a seaside retreat in living next to such a powerful symbol." "It's not a person, it's a structure," she said. "Still, it represents something heroic."

7
Storm Warriors

The Coast Guard in Eastham

A fine group, these wardens of the Cape. Into the worst storm they go—without a question, with never a hesitation—a storm in which life would seem impossible.
—*Henry Beston,* The Outermost House

One summer day in 1935, Boatswain George B. Nickerson and the rest of the crew were going about their business at the Nauset Coast Guard Station. Outside on the beach, picnickers were enjoying the day, but the elements were about to change a lot more than what was going on during this particular day.

The skies darkened, and a thunderstorm was unleashed on the outer beach, forcing the visitors to run for cover. Into the galley of the Coast Guard station they went, continuing their festivities. However, when a few banana peels and sardine cans began to pile up, Keeper Nickerson had a word with his guests about the litter.

Nickerson's concern over banana peels and sardine cans quickly waned when he learned the identity of one of the visitors, who happened to be Henry Morgenthau, the secretary of the U.S. Treasury. Nickerson took his guests on a tour of the station, and Morgenthau began to notice the deteriorating condition of the sixty-three-year-old facility. The government purchased land for a new station two years earlier, but perhaps Nickerson wasn't completely sold on the plans for an upgrade. Nickerson, appointed to the Nauset helm nine years earlier, pointed to where the tides had begun to threaten the foundation, a mere thirty feet away. According to Jeremiah

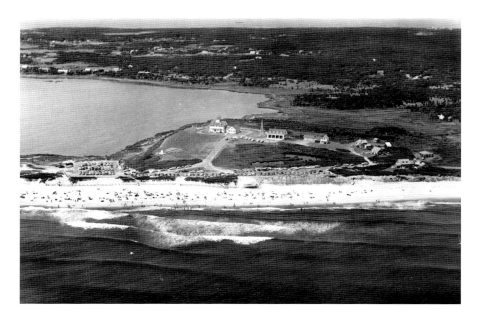

An aerial view of the Nauset Coast Guard Station, along with the parking facilities and bathhouse for Coast Guard Beach, which became part of the Cape Cod National Seashore in 1961. *Eastham Historical Society.*

Digges's book, *Cape Cod Pilot*, "Morgenthau, who had dabbled a bit in stabilization, nodded thoughtfully," as he listened to the Nauset keeper.

Morgenthau was a major player in designing and financing President Franklin D. Roosevelt's New Deal and would later finance the World War II effort through the sale of war bonds. Three weeks later, a new Nauset station was commissioned, and many more would follow.

With New Deal projects already in full swing, more than forty new Coast Guard stations sprouted up across the country, all of which were designed in a uniform Colonial Revival style. The new Nauset station was formally manned on January 9, 1937. The old station was demolished, and the site was soon covered by the waves.

The first Nauset station appeared on the beach in Eastham in 1872, shortly after the establishment of the U.S. Life-Saving Service. Although the Massachusetts Humane Society, a private charity, had been in the business of saving ships in distress since 1785, any state and federal funding only made a small dent in the problem. Shipwrecks became so common on the dangerous shoals of the Outer Cape that the area became known as a graveyard of ships.

The U.S. Life-Saving Service (USLSS) was under the direction of Sumner I. Kimball, a U.S. Treasury clerk and lawyer who was appointed as the chief of the Treasury Department's Revenue Marine Division in 1871. It was under his guidance that the Life-Saving Service evolved into the Coast Guard in 1915. Kimball, according to the Orleans Historical Society, worked briefly as a teacher in Orleans. As Edwin Emery wrote in *The History of Sanford, Maine*:

> *In his later youth* [Kimball] *was also witness to scenes around the ugly shores of Cape Cod, which were well calculated to intensify the earlier impressions; so that from this point of view alone there was much fitness that circumstances should afterwards so happen as to place him at the head of a great organization having for its splendid object the rescue of life from the perils of the sea.*

Kimball sent Captain John Faunce of the U.S. Revenue Marine on an inspection of the lifesaving network, which was particularly sparse on the Outer Cape. Faunce's report used the words *rusty* and *old* in describing both apparatus and personnel. Kimball turned out to be a bureaucratic genius, using Faunce's report and his own political savvy to get $200,000 from Congress to beef up the Life-Saving Service.

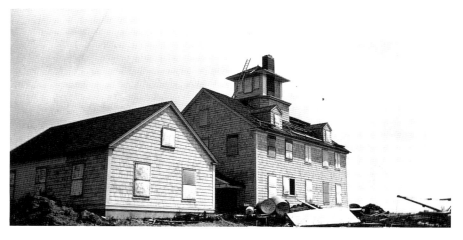

The new Nauset Coast Guard Station under construction in July 1936. Construction was completed by the end of the year, and the new station was commissioned in January 1937. *Cape Cod National Seashore.*

"In what seems like lightning speed by today's standards, Kimball's efforts resulted in nine federally funded lifesaving stations on Cape Cod in 1872," wrote Ron Peterson in "The Lifesaving Legacy of Orleans" for the Orleans Historical Society. Those stations, part of the Life-Saving Service's District 2, were Chatham, Monomoy, Orleans, Cahoon's Hollow, Pamet River, Highland, Peaked Hill Bars, Race Point and Nauset, and they were manned by January 1873.

The Life-Saving Service was in dire need of improving its pay scales and working conditions, and Kimball, who could play the public relations game as well as anyone, succeeded in that quest. He hired William D. O'Connor, a professional author, to write the annual USLSS reports. As Cape Cod Coast Guard historian Richard Boonisar noted in a 2015 interview:

> *O'Connor would exaggerate the facts from the keepers' reports, but keep the facts the facts. Kimball would send these reports to Congress, and when he went for appropriations, Kimball was the ultimate federal bureaucrat in the 1880s and '90s and was the first to retire with a pension. These were written to be read. He got his money.*

"Kimball was unquestionably the driving force behind the United States possessing a first-class lifesaving organization," wrote USLSS historian Dr. Dennis Noble. "Much of the present-day Coast Guard's highly regarded reputation as a humanitarian organization is the result of his organizational skills and management abilities."

According to historical architect Lance Kasparian, in his "U.S. Coast Guard Nauset Station Dwelling and Boathouse Historic Structure Report" for the Cape Cod National Seashore, the nine Cape Cod stations constructed in 1872 were a Red House–type design. "These stations were 1 1/2-story frame structures measuring forty-two by eighteen feet in plan, with shingled walls and gable roof. On the first story were a boat room and mess room with a stove for heat and cooking. On the second story was crew sleeping quarters and a spare room." In his 1928 book, *The Outermost House*, Henry Beston wrote, "[F]rom the west dormitory, a ship's ladder leads through a trapdoor to the tower." In his 1902 book, *The Life Savers of Cape Cod*, J.W. Dalton described the second bedroom as having "spare cots for rescued persons, and is also used as a store room."

In advance of improvements to the station in 1887, the facility was moved one thousand feet to a bluff just north of the original location. Alice Lowe noted that the station was moved a second time in 1900.

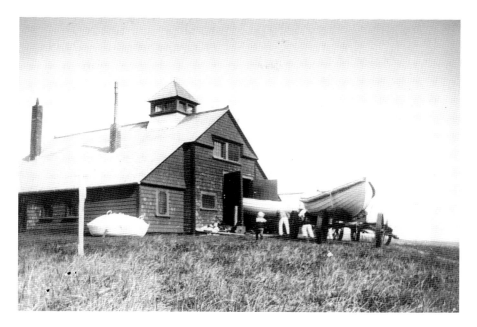

A young Bernard Collins (*left*) accompanies his father, Lewis, a surfman at the Nauset Lifesaving Station, and other surfmen as they move the surf boat back into the station, early 1900s. *Cape Cod National Seashore.*

The Red House–type stations on the Cape were manned from August 1 through June 1, but the keeper stayed on duty year-round. Nauset's first keeper was Marcus M. Pierce, who was appointed at the age of thirty-two on December 12, 1872. Pierce was replaced by Alonzo Bearse, a Civil War veteran, on September 12, 1887. Bearse retired for physical reasons in July 1905, making way for longtime Orleans surfman Abbott H. Walker, whom Henry Beston described as "an expert among surfmen and boatmen, and one of the best liked and most respected men on all Cape Cod." Walker retired in 1926, and he was replaced by George B. Nickerson, who served at Nauset until 1936. Chief Petty Officer C.D. Keegan followed Nickerson.

As Alice Lowe noted, "the north patrol from Nauset was about four and a half miles to a point where the surfman met and exchanged checks with the surfman from Cahoon's Hollow Station. The south patrol of about three miles extended as far as Nauset Harbor where a time clock was used to register the completion of the watch." The checks used at the halfway houses were metal tokens, numbered one through nine. The lower the number, the more experienced and higher rank the surfman had.

A Brief History of Eastham

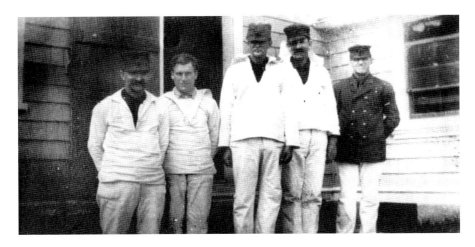

Above: Abbott Walker (*far right*) was described by writer Henry Beston as "an expert among surfmen and boatmen, and one of the best liked and most respected men on all Cape Cod." *Eastham Historical Society.*

Below: Surfmen carried brass tags on their nightly patrols, which they left at halfway houses to indicate that their patrol was completed. The surfmen were ranked one through seven, based on seniority and experience. *Author photo; tags from the collection of Richard Boonisar.*

The tools of their trade were referred to as beach apparatus. Among the items included were a breeches buoy, a Lyle gun (a small cannon), projectiles, a sand anchor and a faking box. These were all pulled down the beach in a cart, by either the lifesaving crew, a horse or, in later years, a tractor. When a distressed ship was spotted, the surfman would light a Coston flare, which would summon those on watch at the nearby station and inform those on board the ship that help was on the way.

Rescues were made using either a surf boat or the breeches buoy if the surf was too high. According to Dianne Greaney of the Orleans Historical

Society, the breeches buoy was "a mortar with a projectile attached to a rope that got shot into the rigging of a sinking ship." The top was a leadline that pulled a heavier rope, the pulley and the lifesaver ring out to the ship. Once the lines were secured, the survivors could step into the legs of the breeches within the ring and be hauled ashore. The Lyle gun (named for its inventor, Captain David Lyle) fired a projectile that flew over the vessel and dropped the line down to the crew, who pulled it aboard and attached it to a heavier whip line.

The line originated out of the faking box, in which the rope was neatly wound. Attached to the line was a tally board, which provided instructions, in English and French, to the crew. The line would then be tied to the mast or other elevated spot on the vessel, creating a zip line between shore and ship, usually pulling in one crew member at a time.

"A breeches buoy is nothing but a heavy pair of pants and a round floating ring on top of it," according to Bernard Collins, who assisted his father, Lewis, a surfman, on rescues from the Nauset Lifesaving Station in the early 1900s. In a 1977 interview with Tales of Cape Cod, he said, "Once they get that off there, whoever's aboard the ship gets in that and the Coast Guard brings it into shore."

Surfmen from the Nauset Lifesaving Station run through a breeches buoy drill. *Cape Cod National Seashore.*

Proficiency was a must for surfmen when it came to setting up the breeches buoys. The best crews could fire the Lyle gun, rig a breeches buoy and haul a person down from the wreck pole in two minutes and thirty seconds. Crews had a five-minute limit to complete the drill; failure to do was cause for dismissal. "The muster at the station must have resembled that at a firehouse," wrote J.H. Mitchell and Whit Griswold in their 1978 book, *Hiking on Cape Cod*.

The mantra of the U.S. Life-Saving Service and Coast Guard was "You have to go out, but you don't have to come back." The surfmen had to deal with cold rain, snow, sleet and wind, but cliffs could also cave in or high surf could suddenly surge in on a beach with no escape route. Helen Chalke, whose husband, Effin, served as a surfman at the Nauset station for about three years during the 1920s, recalled in an interview with the Henry Beston Society in 2009 that it was probably the night patrols on the beach that prompted him to seek employment elsewhere. She noted that those walks, many of which were along the edge of the high dunes in the dark, were frightening experiences.

The blowing sand, however, was what Arthur Wilson Tarbell called "the surfman's worst enemy" in his 1932 book, *Cape Cod Ahoy!*: "Sooner or later it

Surfmen from the Nauset Lifesaving Station strike out through the breakers during a surf boat drill in this undated photograph from Bernard Collins. *Cape Cod National Seashore.*

is certain to give eye trouble, as the artillery of the winds is in action most of the year on this exposed shore. Eyes are filled in ordinary blows, but when a 'snorter' rages the face is often cut until the blood comes. As the driving sand particles can change clear glass into ground glass in a single bad night, you will understand the effect on human features."

The Nauset station was called to the scene for several shipwrecks, including the *Friederich* in 1883, the *Katie Barrett* in 1890 and the *J.H. Ells*, which Joseph Lincoln based his story *Rugged Water* on in 1887. However, one of the most memorable disasters was the loss of the steamship *Portland* on Thanksgiving weekend in 1898. An estimated 192 passengers and crew members lost their lives after the vessel was claimed by the sea near Stellwagon Bank, and the bodies of 38 of those victims washed ashore on Cape Cod's outer beach. As Alice Lowe noted in *Nauset on Cape Cod*:

> *Many bodies and pieces of wreckage came ashore at Nauset. Tales are still being told of the carting of bodies to the railroad station and of distressed relatives waiting anxiously in the Cape towns for their loved ones to be released from the angry seas. The outlines of other vessels had been glimpsed offshore during this storm and were known to have been lost, their wreckage also littering the beach with each return of the tide.*

In November 2015, Rick Lindholm recalled:

> *My great-grandmother talked about the* Portland *when I was young. She told of the bodies found on the beach in Eastham. The funeral home on Bridge Road was full, the ground was frozen, so they kept a lot of bodies in the barn behind her uncle's house.*

According to Eastham's town records, which were registered by George J. Dill and copied for Albert E. Snow by Howard Willis Quinn in 1966, the victims who washed ashore in Eastham were Susan Annie Kelly of Boston, Massachusetts; Eliar Dudley Freeman of Yarmouth, Maine; Anna Augusta Wheeler of South Weymouth, Massachusetts; Eva M. Sotten, Solomon Cohen, Elizabeth M.A. Collins and John A. Connell of Portland, Maine; Harry C. Robinson of Deering, Maine; and Peter Collins of Hanover, Massachusetts. The victims ranged in age from twenty-one to sixty-one.

According to Snow, a retired navy commander from Orleans, there was a survivor from the *Portland*, but the man died before help arrived on the beach. His account for the Eastham Historical Society in 1969 follows:

> *Though bruited that all were lost from SS* Portland, *late Capt Edwin W. Horton (Eastham native)—then a lad of 13, related the amazing word that one of* Portland*'s quartermasters, a giant of a man, known as a powerful athlete and swimmer made Eastham's beach alive, but exhausted. A Nauset-Eastham's station's life-saver, patrolling/searching beach for bodies, came upon the giant, turned the supposed dead body over, for a look at this face, whereupon the giant exclaimed, "For God's sake—don't leave me!" The USLSS Patrolman panicked, ran off to fetch a companion.*
>
> *Upon their return, the giant meanwhile had succumbed, thus sealing forever the ungarbled word upon what actually befell SS* Portland, *9:15 AM Sunday, 27th of November, 1898, conceded the worst storm and life loss in the annals of Mass., and Cape Cod's long maritime history. Foregoing largely from my father, Frederick Warren Snow (1858–1940) in Boston Pilot vessels from 1873–1893, a friend of Capt. Hollis Blanchard (1838–98), universally blamed for being a foolhardy mariner in leaving Boston harbor that fateful night, and heading into one of the coast's greatest storms, even today—1969, 71 years afterward, referred to as "*The Portland's Gale.*"*

Another memorable disaster involving the Nauset crew happened just to the north, near the Marconi Wireless Station in Wellfleet, on February 17, 1914, when the Italian bark *Castagna* ran aground during a northeaster. The stormy and icy conditions claimed five lives.

The *Castagna*'s crew of thirteen had spent two months at sea, hauling a load of guano and cattle horns from Montevideo, Uruguay. Dressed in summer clothes, the men were no match for the single-digit temperatures, howling winds, driving snow and pounding surf of a Cape Cod winter. When the ship struck the bar, the men climbed into the mizzenmast. The captain fell, hit his head on the icy deck and was swept away by a wave. The cabin boy met a similar fate. Two other men froze to death in the masts, turning their bodies into mummies encased in ice.

Fortunately for the rest of the crew, the crews of the Nauset and Cahoon's Hollow Lifesaving Stations were able to reach the ship. The first mate, barely alive, was frozen to the wheel, but he was eventually freed when young Bernard Collins, son of Nauset's No. 1 surfman, Lewis Collins, sawed away the spoke that the crew member's hand was frozen to. The man died shortly after, but thanks to the heroic efforts of the lifesavers, the remaining eight crew members were saved.

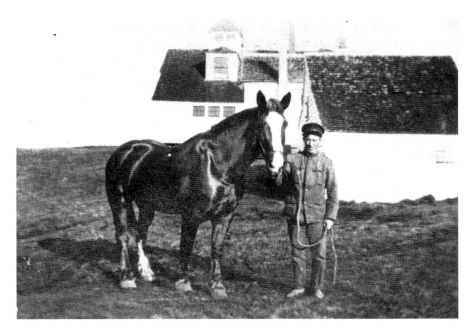

Surfman Wilbur Chase, shown here with the Nauset Coast Guard Station's horse, served at Nauset and other Outer Cape stations in the early part of the twentieth century. The horses were used to pull surf boats and beach apparatus to shipwreck scenes. *Mary McDermott.*

The Nauset crew was summoned to the scene in Orleans when the *Montclair* ran aground on March 5, 1928, and "went to pieces in an hour," according to Henry Beston in *The Outermost House*. Keeper Edward Clark and two surfmen, Wilbur Chase and John Adams, were on duty that fateful morning at the Orleans station, which was in the process of being shut down. By the time that help arrived, five men had perished. A full staff was reinstated to Orleans later that year, but as Isaac M. Small, author of *Shipwrecks on Cape Cod*, noted, "[T]his seems to be another case of locking the stable door after the horse has been stolen."

The outcome was a much better one for the *Anna Sophia* off Eastham in March 1934. In an event that involved Cape Codders, Coast Guardsmen, captains and canines, keeper George B. Nickerson and the crew of the Nauset station pulled off the heroic rescue of the five-man crew and its poodle mascot, Spud, in subzero temperatures from the distressed 102-foot vessel bound for Maine from New York. The crew had to find an opening through a wall of ice that had built up along the shoreline. The crew's tractor

A Brief History of Eastham

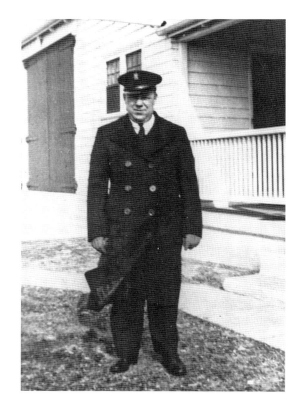

Left: Yngve Rongner, a longtime surfman at the Nauset Coast Guard Station. *Cape Cod National Seashore.*

Below: Surfmen from the Nauset Lifesaving Station head out to a rescue with a Monomoy surf boat in this undated photograph. Note the cork-tubed life jackets worn by the sur men. *Cape Cod National Seashore.*

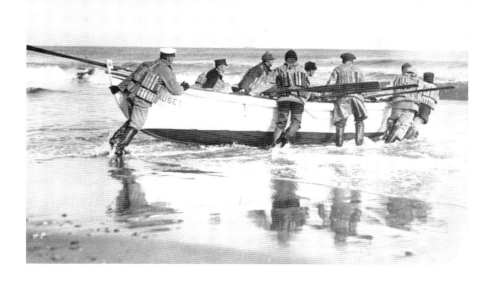

pulled its Monomoy surfboat nearly two hundred yards down the beach before a suitable opening for a launch could be found.

The crew of Nickerson, Joseph Berbine, Yngve Rongner, Ralph Ormsby, Jules Serpa, James Brown and Henry Hautenan rescued the ship's crew, including Spud. As the February 10, 1934 edition of the *Boston Globe* put it, "When the surfboat and her load of hardy Maine fishermen rode through the breakers to an ice caked shore, 'Spud,' got a shower of surf, but dashed out of the arms which held to greet the Coast Guard station's mascot, Rex, a big police dog, which awaited the return of his masters."

After the Cape Cod Canal opened in 1915 and was expanded by 1935, the number of shipwrecks along the Cape's outer beach began to decline, and Coast Guard stations began to close. The Nauset Coast Guard Station was decommissioned on September 15, 1958. "With the exodus of its equipment Tuesday, the Nauset Coast Guard station in Eastham officially went out of existence. Various Coast Guard stations on the Cape and at Boston hauled away the gear which had been there for many years," stated the September 25, 1958 edition of the *Provincetown Advocate*.

The Cape Cod National Seashore used the building as its temporary headquarters when it opened in 1961. In recent years, the Cape Cod National Seashore overnight NEED (National Environmental Educational Development) program for school groups has called the old Nauset station home. The park also has a plaque on the overlook in front of the station that tells the stories of the U.S. Life-Saving Service and Coast Guard at Nauset. Today, the Cape Cod National Seashore offers reenactments of the Coast Guard's rescue drill at the old station at Race Point in Provincetown.

Coast Guard Beach is now one of the most popular beaches in the country, but the motto of the Coast Guard—"Semper Paratus"—and its spirit continue to hover about this outermost outpost.

8
Tales of the Eastham Rumrunners

One fall day in 1933, Arthur Nickerson came home from school, still dressed up, sporting gray flannel pants and white sports shoes. Upon his arrival, his mother had other plans for him.

"Don't stop now," she said. "Go down to South Sunken Meadow Beach. There's a load of booze ashore."

The era of Prohibition, brought on by the passing of the Eighteenth Amendment by Congress twelve years earlier, was in its final days. Since 1921, "the manufacture, sale, or transportation of intoxicating liquors within, the importation thereof into, or the exportation thereof from the United States and all the territory subject to the jurisdiction thereof for beverage purposes [was] hereby prohibited." This referred to anything containing at least .01 percent alcohol.

Nickerson wasted little time in getting to the beach, located on the bay side of Eastham. The tide was high, but Nickerson still waded out into the rising water to retrieve the illegal—yet coveted—cargo, which had been cast overboard from rumrunners fleeing the Coast Guard. "I made enough money that afternoon…to buy a 1931 Chevrolet roadster and finance my Washington [D.C.] trip the following spring," Nickerson recalled in an Eastham Historical Society interview in 1982. "That's an example of what went on."

Booze was big business along the Atlantic Seaboard during that era, and Cape Cod was in on the party, as more than a few people were willing to look the other way. "I've never known a law which was so enthusiastically

A Brief History of Eastham

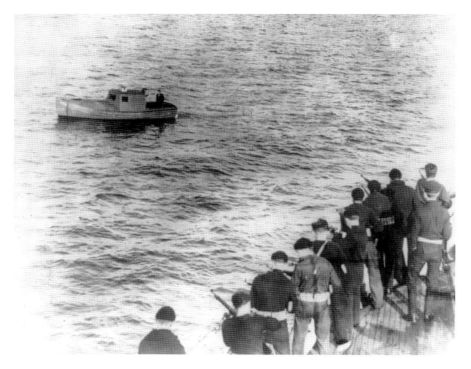

A typical scene when the Coast Guard caught up with a rumrunner at sea during the Prohibition era. The Coast Guard was often well armed in their pursuit of rumrunners. *Library of Congress.*

violated, with the possible exception of the fifty-five-mile-per-hour speed limit," longtime Eastham resident and historian Don Sparrow said in an interview with the Eastham Historical Society in 1991.

A few locals were in the business of making bathtub gin, wine or beer, but offshore ships from Canada and Europe provided a steady supply of whiskey, cognac, wine and champagne to Cape Cod rumrunners, such as Prescott "Bud" Cummings, Sparrow's neighbor on Nauset Road. Cummings first came to Eastham to be a turnip farmer but made little money at it, and he turned to the much more lucrative profession of rumrunning. As Cummings told Sparrow in a 1983 Eastham Historical Society interview:

> *The bootlegger made gin, bathtub gin, peddled it around town and so forth. Or he may have been on the angle of distilling anything from grains to*

> *garbage and making alcohol, and in the process blinding and killing a few people. But the rumrunner was strictly on the water, and he ran the liquor from the offshore ships to the shore, and was probably involved in getting it from the shore to wherever their warehouse was.*

"[Cummings] told me that he got about $5 for every case that he dropped from the rumrunners to the shore and over a period of time, a couple of years when he was doing the rum running, he brought in forty thousand cases," Sparrow said, noting that added up to $200,000. This proved to be quite lucrative during the Depression era, "so rumrunning was important to the economy of Eastham."

The Coast Guard's jurisdiction extended to twelve miles offshore. "They had to be well beyond there to be safe, because sometimes the government stretched the mileages a little or shortened them up a little bit too," Cummings noted.

Cummings worked for a man in Scituate, Massachusetts, who operated a fifty-foot boat out of Scituate Harbor. It had three five-hundred-horsepower motors in it, capable of speeds of fifty miles per hour, easily outpacing the Coast Guard destroyers, which could manage only thirty-six miles per hour. Cummings would sit around with his employers playing cards until the call came in to pick up a load offshore, beyond the twelve-mile limit, in an offshore area known as Rum Row.

Sparrow said that Cummings and his co-workers, after paying for their liquor in Boston,

> *were given a five-dollar bill torn in half, a half that was good for five hundred cases waiting from the ships that were waiting in Rum Row. Bud said that there were destroyers out there with searchlights sweeping around, surveying the scene. There would be French sailors hanging from the rigging equipped with machine guns, not to repel the navy but to protect themselves from hijacks who might try to take the whiskey away from them.*

The cases were unloaded into the smaller boats, and when they reached Cape Cod Bay, they had to deal with the local Coast Guard and somehow get the whiskey ashore. After that, they had to worry about local police. The whiskey was packaged in corrugated cases or just whiskey bottles wrapped in straw, with burlap around them and tied up so they could be lifted by the "ears." Sparrow once described the situation to a group of Eastham students:

> *They might talk to a quahogger and say "How would you like to make some money and bring fifty cases of liquor in for me?" They might get it in that way. Or, they would just run it ashore late at night—they would have a gang organized to unload the cases from the larger boats. Then they would put it in the trucks and take it to a place they called a "drop." It was an unused garage or barn where they could store it until they could take it to market.*

Arthur Nickerson always suspected that "Ray Carter's shellfish place at Rock Harbor" was a hotbed of activity. "I've got a feeling there was a good many hundreds of cases went through that building," he said. During the same interview, Joe King recalled working there, barreling quahogs, and confirmed that there was an efficient system in place to run the liquor through:

> *You know, when you just took in a boat, you could tell if she was loaded too deep. See, that's where they'd transfer. And the biggest truckers off the Cape—you wouldn't believe it—was Standard Fruit of New Bedford at that time. You could always see them come down to buy turnips and buy carrots. They were the biggest supplier. They'd rather have a load of carrots, because they'd pack better in the truck, on the side rails. These are rack trucks. Then they'd put the booze in the middle.*

Cummings recalled that many of the local authorities were in on the action: "One house we used, the chairman of the selectmen owned the house. Two of the local officers worked with us. And the one state policeman that was supposed to be untouchable in those days was paid off. So we had things pretty much our way."

Sparrow told a story of how the Coast Guard once intercepted four hundred cases of whiskey in Boston, but most of it mysteriously disappeared in Eastham under the care of Keeper Henry Daniels at the Nauset Coast Guard Station: "They didn't have room in the storehouse there, so they asked Captain Daniels if he would store it for about a month until they had room for it in Boston. So they had four hundred cases in the boat house there and when they came back a month later there were four cases left—miraculously it had shrunk!"

Not all Coast Guard officers got off so easily. Leroy Richardson told Sparrow about a Coast Guard officer who took some confiscated liquor

and hid it in back of Doane Rock, about a mile west of the Nauset station. "As he unloaded it we loaded it right back up," Richardson recalled. "We knew damn well nothin' he could do about it." The officer was eventually dismissed.

According to the *Cape Codder* newspaper's "Memoirs of the Rum Runners" columns, which ran in December 1951 and January 1952, the rumrunners "were outlaws," but there was very little, if any, bloodshed: "There was one unsolved murder in the township of Barnstable—a group of young bloods tried hijacking and were ambushed. As a rule, the rumrunners were very restrained as to gun play in the operations on Cape Cod. There is no record of the numbers of beatings that may have been administered when amateurs got in their way."

The big markets for the contraband liquor were in Boston and New York, as Sparrow recalled:

> Bud [Cummings] *told me that typically they would have a convoy of three vehicles, they would have the whiskey in a truck and ahead of the truck would be a convoy of three vehicles. There would be a car ahead of the truck with rumrunners paying off police officials in the various towns. Behind that car would be another car with men and machine guns, to protect themselves from hijackers.*

Rumrunners always had a fistful of cash on hand, usually to pay off authorities or get themselves out of predicaments. On one occasion, the convoys were going over the Cape Cod Canal, and a Salvation Army man in uniform happened to be walking over the bridge. The rumrunners thought he was a police officer, so they stopped and gave him $500. "He was very, very pleased and had a good view of the Cape Codders' generosity," Sparrow recalled. The man ended up giving the cash to the Salvation Army, possibly because the story quickly hit the newspapers.

In "Memoirs of the Rum Runners," written under the pseudonym "Cal, the Clam," the paper reported, "Many of the people in this series will have fictional names for obvious reasons, but the facts put forth will, to the best of our knowledge, be true."

One of the columns told the story of "Joe," an old farmer who often went out at night and checked on his animals after returning home. One night, at 1:00 a.m., he came home to find his barn door wide open, with a truck in the doorway. He quickly found himself face-to-face with a gun-toting rumrunner. "It's okay, Pop," said the man. "We're staying here because there

was a tipoff up the line. We'll be leaving before daylight. Go into the house and go to bed—don't try to use your telephone. We'll take care of you." The next morning, Joe came to the barn and found the door carefully closed, and on the floor just inside were two full burlap sacks of whiskey just off the boat.

While many runs were successful, others weren't so lucky. According to Sparrow, one quahogger had a load on board and was late getting into Rock Harbor, so he stayed offshore until the tide was right, but the Coast Guard caught him, resulting in a typical penalty—he lost his boat and was assessed a fine of $10,000. When he raised enough money and bought another boat, he christened it *Never More*.

Two Nantucket rumrunners enlisted the aid of their twelve-year-old niece from Orleans, Reta Cummings, who would later become Mrs. Don Sparrow. She would go to Nantucket to visit with her aunt and uncle for a couple of weeks each summer. They ran several Nantucket enterprises, including a laundry, a fish distributor and other things, but they were also bootleggers, so a bottle or two would often be included with their business deliveries.

On one occasion, a state police officer caught them and took them to the station for interrogation, but the youngster pleaded ignorance when it came to her aunt and uncle's activities. She was on the first boat home the next day. As Sparrow revealed in 1991, "Today she is very proud to be called the youngest rumrunner on Cape Cod."

The rumrunners were often forced to dump their cargo overboard if they were in danger of being intercepted by the Coast Guard. Cummings told Sparrow the rumrunners would load many of the cases on the edge of the boat and kick over the first case of whiskey—all of the others would be dragged along with the rope. Then they would have a buoy at the tail end of this, but the Coast Guard would see it, so the rumrunners put a block of rock salt on the buoy. The salt would dissolve in a few days, leaving the floating buoy to mark where the load was dumped.

On many occasions, the liquor wouldn't be recovered by the rumrunners but lucky Eastham residents. In an interview with Sparrow for the Eastham Historical Society, Leroy Richardson recalled digging up bottles of whiskey from the bottom of Cape Cod Bay "hundreds of times." Richardson said that a rumrunner dropped liquor right off Sunken Meadow, and "Warren Baker and I were out that night and heard something." They returned the next morning and found the liquor, most of it Charleston scotch.

The October 28, 1932 edition of the *Boston Globe* reported, "[F]ortunate fishermen and townspeople are believed to have salvaged approximately four hundred cases of choice liquor" after a rumrunner's speedboat struck

a bar at Sunken Meadow Creek. Although the crew managed to salvage two hundred cases, the *Globe* said "a group of one hundred citizens and four truckloads of Coast Guardsmen searched the beach in inclement weather for the liquor."

The *Cape Codder*'s "Memoirs of the Rum Runners" columns told the story of how a dumped liquor load became the main attraction of a birthday party at a bayside home around Christmas time. The liquor load was left at the end of an inlet on the man's property—over one hundred burlap sacks of whiskey, brandy and champagne—and he quickly carted it all off in his truck.

The *Cape Codder* also recalled the story of a smuggler who was highly regarded by "syndicate bosses in Boston." His speedy vessel was capable of carrying five hundred to six hundred cases of liquor, "with bulletproof glass and steel sheathing near the wheel." One night, the Coast Guard had him on the run and fired a hail of bullets over the boat, but the rumrunner escaped.

The next day, the Coast Guard captain spotted the man on a wharf. "You got away last night," the officer said.

"Me?" the rumrunner sarcastically replied.

"No bullet holes," the captain remarked. "We may get you next time."

At that moment, the "big fellow" just grinned. "You'll never catch me."

The Eighteenth Amendment was repealed on December 5, 1933, with ratification of the Twenty-First Amendment to the U.S. Constitution.

Many of the former rumrunners were able to invest in real estate and go into business. Cummings, for instance, opened and ran the Aquanon, an Orleans nightclub, became a gold miner and prospector in Alaska and ran an import-export business in Mexico before returning to Eastham to become a builder and selectman. "He became one of Eastham's distinguished citizens," Sparrow noted.

Cummings said that the end of Prohibition "was like an automobile assembly plant had been shut down. People were out of work, and the fun was over." He admitted that even if he hadn't been paid for doing this he would have still done it because "it was so much fun."

9
THE "OLD HOUSE OF LEARNING"

The old schoolhouse stood unwanted, unloved, and deteriorating.
—*Frederick Jewell, 1967*

Situated in the heart of Eastham's Historic District is one of the town's historic icons: the old Eastham Schoolhouse. Today, it houses many of the old artifacts from the town's past. Eighty years ago, it was the "old house of learning," as Frederick Jewell noted in an article for the *Cape Cod Standard-Times* in 1967.

Tales of the old schoolhouse are still told, some by students who actually attended classes there or their children. The two doors, one for boys and the other for girls, are still there, but only the girls' door has been used in recent years. Don Sparrow often remarked that he was still apprehensive about entering the building through that doorway, even though it had been more than sixty years since he graduated from the school.

In the mid-1800s, there were four districts. According to Alice Lowe, "The number one schoolhouse was on the Bridge Road, number two on the main road…number three at the junction of Nauset Road, and number four on the main road in North Eastham." The number two was abandoned in 1878, and the number one was moved to a new location on the Town Cove.

In 1902, the three schools were moved together to form a new three-room grammar school at the Nauset Road location. The *T*-shaped configuration had one building in the front and the other two at right angles. The buildings

A Brief History of Eastham

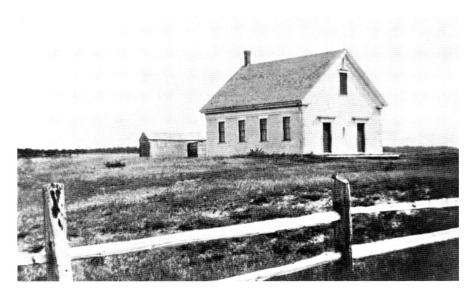

The lone Eastham Schoolhouse prior to 1902. *Eastham Historical Society.*

housed the primary, intermediate and grammar schools. While the work was being done, classes were held at the old town hall.

Sparrow, who attended the schoolhouse in the early 1930s, wrote in his book *Growing Up on Cape Cod*, "[C]lassrooms were equipped with twenty to thirty wooden lid-top desks, each with an attached seat and iron grillwork legs screwed to the floor." He added that "classes were small, not more than twenty students in each of the three classrooms, and so we received lots of individual attention."

The history of the schoolhouse wouldn't be complete without mentioning Otto Nickerson, whom George Rongner referred to as the school's "strict but renowned principal." Nickerson taught in Eastham Elementary Schools for forty-three years, first arriving in 1918. Nickerson stayed for three years, moved to North Andover and Newton for the next three years and returned to Eastham for good. Students always attempted to steer clear of Nickerson's disciplinary measures. Sparrow recalled meeting up with "Mr. Otto" in 1992: "When I commented that we had greatly feared triggering his wrath, he seemed pleased."

There were no organized sports or play at recess; the youngsters played games such as "tag, prisoner's base, hilly-hi-over, Rover Red Rover and other schoolyard games," Sparrow recalled. Music and art teachers visited once

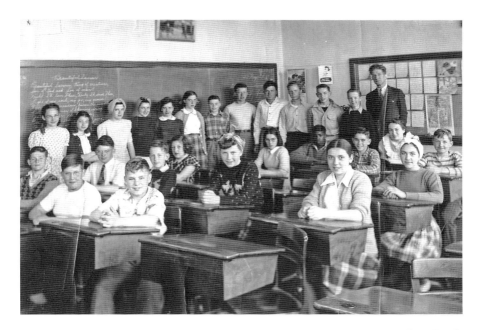

Above: Principal Otto Nickerson (*back row, far right*) with an eighth-grade class in this undated photograph. *Eastham Historical Society.*

Below: A music class from the Eastham Schoolhouse in 1936. Thomas Nasi, pictured in the very top row at the right, was the music teacher who visited the school once a week. *Eastham Historical Society.*

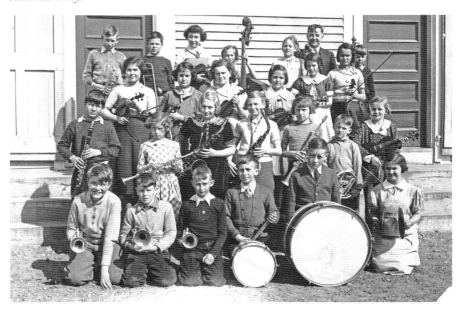

a week. "Musical education received a lot of attention," Sparrow noted. Thomas Nasi was the director of musical education for the Outer Cape school systems, and learning a musical instrument was required of all students. "Mr. Nasi tried to hide his anguish as we tooted and banged away during practice."

Musical instruments were a big part of the day when the schoolhouse students moved to the new elementary school during the fall of 1936, leaving the old building behind. A long procession of students, armed with their books and other possessions, paraded down Schoolhouse Road to the new facility, which is still in use today.

With the move to the new school, the two wings on the north end of the building were sold off, and the original schoolhouse was left empty. For a while, new owners converted it into a cottage, but they later abandoned it. By 1963, the building and property had begun to deteriorate, and its future was in doubt.

Then, in 1963 came the formation of the Eastham Historical Society. As Frederick Jewell, one of the early organizers of the group, noted in

The Eastham Schoolhouse prior to its renovation as a historical museum. After the school was closed in 1936, the building was converted to a cottage but eventually abandoned. *Eastham Historical Society.*

The renovation of the Eastham Schoolhouse begins to take shape in this photograph from 1965. *Eastham Historical Society.*

a July 2, 1967 article for the *Cape Cod Standard-Times*, the possibility of the old schoolhouse being purchased, restored and made into a museum was brought up in May 1963. Fundraising activities, such as placing miniature schoolhouse collection boxes in stores, book sales and lectures by Sandwich historian Eugene Clark, set the mission to restore the building on its way.

Jewell recalled in a 1981 interview with the Eastham Historical Society that when the question of using the schoolhouse for a museum came up, Ralph Chase knew the owner of the building. Jewell then contacted her, leading to the acquisition. Ralph Chase, Captain Robert Sparrow and Bernard Collins advanced $8,000 to buy the building, which was eventually paid back. Nickerson Lumber Company gave shingles for the new roof, while many other businesses and residents made contributions.

The society took title to the property in May 1965. Jewell recalled, "The 'old house of learning' stood in a sad state of affairs. The roof leaked badly, the windows were broken and boarded up, the floor rotted through in places, the grounds were overgrown with weeds, shrubs, and trees. The

signboard announcing the restoration project was the only bright spot on the premises."

Today, the schoolhouse is listed in the National Register of Historic Places, and a new wing was added on the northeast side of the one-room classroom in 2008. The classroom is now what the Eastham Historical Society calls "a children's 'hands on' museum," complete with its original schoolmaster's desk. The classroom is furnished to replicate how it looked in earlier days. Every spring, fourth graders from the Eastham Elementary School visit the old classroom, getting a chance to learn what the school experience was like so long ago.

10
Captains of Eastham

That arctic wheelman, chief of his clan—himself a history, with his house full of Arctic bear robes, himself hunted down, and a man whose record Cape Cod history will not willingly let die.
—*E.G. Perry on Captain Edward Penniman, 1898*

In the extensive annals of Eastham, there's an abundance of legendary sea captains: Ezekiel Doan, Isaac Freeman and Luther Hurd, just to name a few. The list goes on and on. However, some of the most memorable seafaring tales are those of Captain Edward Penniman, whose legacy is on display at the Fort Hill house that bears his name; Freeman Hatch, whose ship, *Northern Light*, sailed from San Francisco to Boston in a record seventy-six days; and Hoppy Mayo, whose trickery led to the capture of a British warship in Cape Cod Bay during the War of 1812.

Edward Penniman

"Sea Captain of Romance"

With the exception of his son, Eugene, Edward Penniman was the only deep-sea whaling captain from Eastham. To use a baseball metaphor, Penniman could very well be considered the Babe Ruth of whaling captains. *The History of Barnstable County, Massachusetts*, notes that "on various voyages,

A Brief History of Eastham

[Captain Penniman] took 4237 bbls. [barrels] of sperm oil, 12,096 bbls. of whale oil and 166,871 pounds of whale bone."

His obituary stated,

> With his stalwart physique and commanding features, he looked every inch the sea captain of romance in the days of Cape Cod's prominence on the seas, and where the square-rigged sailing ship was still the beautiful queen of the ocean.…He sailed all over the globe in search of those valuable commodities which can only be obtained from the great mammals and leviathans of the deep, and was so successful that at fifty-three he was able to retire with his family with a considerable fortune to the comfortable home on the premises of which he was born.

Edward Penniman was born in Eastham on August 16, 1831, the son of Daniel and Betsy Mayo Penniman. His grandfather, Scammel Penniman, was the first member of the Penniman family to acquire land at Fort Hill, purchasing the former Thomas Knowles homestead in 1829, according to Andrea M. Gilmore's "Historic Structure Report, Captain Edward Penniman House" for the Cape Cod National Seashore.

He was only eleven when he embarked on his first voyage, as a cook on a schooner bound for the Grand Banks off the coast of Newfoundland. The first voyage was a dangerous one, but as a mate or captain, he was never involved with a shipwreck. Oddly enough, all of those vessels met tragic ends under the guidance of other captains, an item that was featured in the *Ripley's Believe It or Not!* column.

Captain Edward Penniman. *Eastham Historical Society.*

After spending his teen years fishing in Eastham and the surrounding area, it was on to New Bedford, the whaling capital of New England, in 1852. Here, the twenty-one-year-old Penniman went to sea as a blubber hunter aboard the *Isabella*. According to the November 6, 1904 edition of the *Boston Globe*, "When he presented himself to the agents, Captain Orrick Smalley, who was in command, was so pleased with his appearance that he signed him as a boatsteerer. The young man at the

time knew more about striking a whale than a Hottentot does about running a locomotive." Penniman was a quick study, though. By his second voyage, he was promoted to second mate and in command for his third voyage.

Three voyages on the *Minerva* followed between 1855 and 1868, two of them to the South Pacific and the last one to the Arctic. These were followed by the Arctic-bound *Cicero* from 1874 to 1875; the *Europa* from 1876 to 1879 to the Coast of Patagonia; and the *Jacob A. Howland*, going to the Arctic from 1881 to 1884. On all these voyages, New Bedford was his home port. On many of these voyages, his wife, Gustie, and their children would join him.

Betsy "Gustie" Penniman. *Eastham Historical Society.*

While Penniman enjoyed tremendous success in whale hunting, the same couldn't be said for his experiences with a polar bear cub. In 1864, on a voyage to the Arctic aboard the *Minerva*, Penniman spotted a polar bear and the cub on an ice floe. According to Jim Coogan in a 2012 article for the *Barnstable Patriot*, Penniman and his crew killed the mother bear but captured the cub, thinking that he would "make a fine playmate for the boys." The cub, however, had other ideas. After being locked away for the night, the bear began to howl and then escaped, chasing members of the crew into the rigging and the shelter of the foc'sle before jumping overboard and swimming away.

The last *Minerva* voyage wasn't only dangerous to Penniman and his crew because of polar bears. The *Shenandoah*, described as a "Confederate cruiser" by Eastham historian Alice Lowe and "a privateer ship attempting to burn whaling vessels" by Andrea Gilmore, was on the lookout for Penniman and determined to sink the *Minerva*. A French captain tipped off Penniman about the *Shenandoah*, and on June 5, 1864, Penniman spotted the Confederate vessel. The *Minerva* fired a cannon at the *Shenandoah*, putting a hole in the deck and damaging the cabin. The *Shenandoah* sailed off and was not seen again. Gustie Penniman was showered with broken glass from the cabin skylight as she was working on an embroidered scarf at the time. The scarf was later preserved in a beautiful hand-carved box by the captain.

A Brief History of Eastham

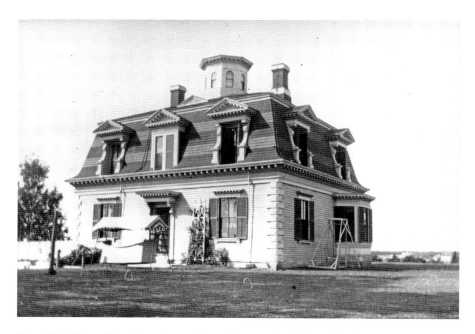

Above: The Edward Penniman house, shown in an undated photo. *Eastham Historical Society.*

Opposite, top: A whale jawbone stands over the entrance to the yard of the Penniman House, now a museum of the Cape Cod National Seashore. *Author's collection.*

Opposite, bottom: Captain Edward Penniman and wife, Betsy, also known as Gustie. *Eastham Historical Society.*

Shortly after returning home from this voyage, Penniman purchased twelve acres of land at Fort Hill from his father. An unknown architect produced high-quality floor plans for a Victorian house, which, according to the Cape Cod National Seashore, had "yellow clapboards, white trim, black window sashes, green window blinds, and brown and red roof shingles." It was the first home in Eastham with indoor plumbing. It also featured a gateway made from a whale's jawbone, a barn and a wooden fence.

His voyage aboard the *Europa*, which concluded in 1879, "resulted in the taking of 1,200 barrels of sperm oil, 4,200 barrels of whale oil, and 20,000 pounds of whalebone," according to the November 6, 1904 edition of the *Boston Globe*. "This voyage is the talk of whalemen today, as oil and whalebone when the ship returned to her home port brought a great price."

The *Europa* voyage, according to both Gilmore and Lowe, was not without peril. In 1877, the crew docked and went ashore for a hunting

On the Outer Beach of Cape Cod

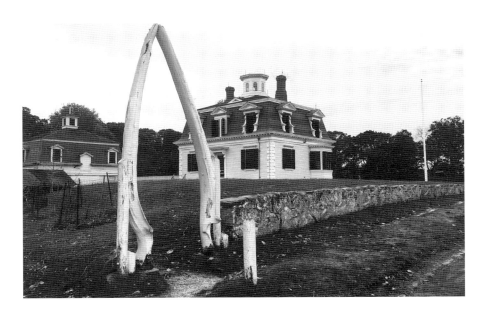

A Brief History of Eastham

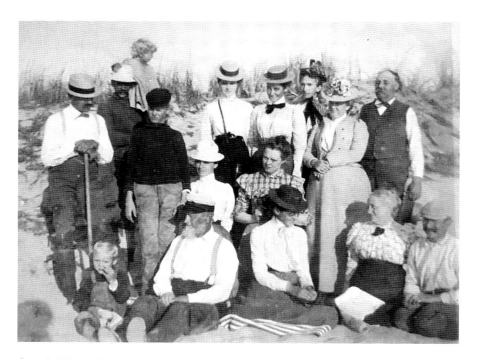

Captain Edward Penniman (*in front, second from left*) and his wife, Betsy (*in front, second from right*), at a beach party. *Eastham Historical Society.*

expedition to replenish the ship's food supply, leaving Gustie Penniman and a skeleton crew on board. While they were gone, a hurricane struck, blowing the ship out to sea. Fortunately, the captain's wife and the few men aboard managed to steer the ship back to land, where they picked up Penniman and the rest of the crew three days later.

Upon the *Europa*'s return to Cape Cod in December 1879, "a brilliant company of our ladies and gentlemen, numbering some fifty or sixty," greeted the Pennimans with a surprise party at their seaside mansion to celebrate the prosperous three-year voyage, according to the January 1, 1880 edition of the *Provincetown Advocate*.

Penniman's voyage aboard the *Jacob A. Howland*, from 1881 to 1884, would be his last. Afterward, the captain retired to his Fort Hill home, opting for a life as a small-scale farmer. He owned two cows and a flock of chickens and had a large vegetable garden and a greenhouse where he raised chrysanthemums.

Penniman was also a philanthropist, especially as a "stalwart pillar" of the First Universalist Church in Eastham. The captain was one of twenty-

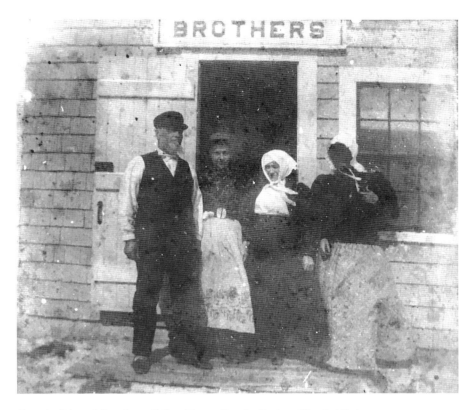

Captain Edward Penniman (*left*) at Nauset Beach. *Eastham Historical Society.*

three members present at the group's first meeting, held in Eastham's Town Hall on August 12, 1889, which led to the construction of the building now known as Chapel in the Pines on a Samoset Road site donated by W.H. Nickerson. To cover the $2,300 cost of the building, Penniman headed a "subscription list for the necessary funds and [took] untiring interest in the completion of the edifice," according to the church's records.

The chapel, which the 1995 Eastham Historic Properties Survey describes as the "only surviving historic, ecclesiastical building in Eastham," is now home to the Nauset Fellowship (Universalist-Unitarian) and the First Encounter Coffeehouse, a folk music mecca on the Cape since 1974. The forty- by fifty-foot chapel is also immortalized on canvas (*Church in Eastham*, Edward Hopper, 1948) and film (Norman Mailer's *Tough Guys Don't Dance*, 1987). After Penniman died at his home on October 16, 1913, his obituary said "that his loss will be a staggering blow" to the church.

A Brief History of Eastham

Edward Penniman was one of the original members of the First Universalist Church in Eastham. To cover the $2,300 cost of the construction of Chapel in the Pines, the captain headed a "subscription list for the necessary funds and [took] untiring interest in the completion of the edifice," according to the church's records. The building is the only surviving historic ecclesiastical building in Eastham. *Eastham Historical Society.*

Edward and Gustie Penniman are shown scaling Enoch's Rock, also known as Doane Rock, in this undated photograph. *Eastham Historical Society.*

The Penniman house remained in the family until June 7, 1963, when Maurice Broun and Irma Penniman Broun sold it to the Cape Cod National Seashore for $28,000, according to the park's records. It now serves as a museum, telling the story of Penniman, his family and New England whaling.

Gustavus Swift Paine described Penniman in the March 8, 1951 edition of the *Cape Codder*: "He had a stalwart physique, commanding features, and in his old age a sort of oval white chin beard. A cordial, genial man, he was warm in friendship and generous in philanthropy."

Hatch's Record Voyage

Captain Freeman Hatch is forever remembered in his native Eastham for his noteworthy accomplishment at the helm of the *Northern Light*, which sailed into Boston Harbor from San Francisco on May 29, 1853, after seventy-six days and five hours.

Hatch, the son of Freeman Hatch and Abigail Mayo, was thirty-three years old at the time of this passage. As Alice Lowe noted in *Nauset on Cape Cod*, the *Northern Light*, built by Edwin and Harrison Briggs of South Boston and owned by James Huckins of Boston, took a respectable 117 days to reach San Francisco from Boston on its outward passage. Arriving shortly thereafter were a pair of New York clipper ships: the *Trade Wind* and the *Contest*. As is the case today with the New York and Boston baseball teams, a competitive rivalry simmered between the two cities. For the return trip, a three-way race was proposed. The New England Historical Society noted that if Hatch and *Northern Light* could beat the *Trade Wind*, Hatch would be the proud recipient of a new suit of clothes, courtesy of a Boston merchant.

The ships left San Francisco on March 12–13, 1853, with *Northern Light* departing last. *Northern Light* didn't take long to bypass the *Trade Wind* and eventually caught up with the favored *Contest* at Cape Horn, at the southern tip of South America, after thirty-eight days. "Off Cape Horn, the *Northern Light* came up with and signaled the *Contest*, and from there led her home by three days," wrote Arthur H. Clark in 1910's *The Clipper Ship Era*. Hatch's ship was off Rio de Janeiro after fifty-two days, and twenty-four days later, it was cruising into Boston. Its best day's run was 354 miles. As Clark wrote:

> *Captain Hatch…was a thorough clipper ship captain, who never allowed his ship to suffer for want of canvas, and on this passage he brought his*

> *vessel across Massachusetts Bay before a fresh easterly breeze, carrying her ringtail, skysails, and studdingsails on both side, allow and aloft, until she was off Boston Light—a superb marine picture, and one seldom seen by landsmen even in those days.*

The next day, Hatch went ashore and was driven to see Huckins, whom Hatch woke from a sound sleep. "Here I am with the *Northern Light*, but I've strained her dreadfully getting here!" the captain said, according to the New England Historical Society. That was fine with Huckins—beating the *Contest* was his only concern.

Hatch died in 1889 and was buried in Eastham's Evergreen Cemetery. His gravestone notes his accomplishment, calling it "an achievement won by no other mortal before or since."

The Heroics of Hoppy Mayo

The War of 1812 happened over two hundred years ago, but Captain Matthew Hopkins "Hoppy" Mayo is still fondly remembered as one of the great American heroes of the conflict.

As the story goes, two Eastham captains, Mayo and Winslow Lewis Knowles, delivered a load of rye to Boston in a whaleboat during the summer of 1814 but were captured by the British fleet, which had set up a blockade of Boston in Massachusetts Bay. Michael Fitzgerald described the situation in his 1912 book, *1812: A Tale of Cape Cod*: "The plight of Eastham in those days was that of many other towns on the Cape. The seafaring population of the district was utterly at the mercy of the enemy and all trade was at a standstill in consequence of the embargo on commerce."

Knowles was released, but only to obtain a ransom to pay for Mayo's freedom. Mayo and the British officers were hardly strangers, and the Eastham captain was enlisted to help navigate the ship through the treacherous waters of Cape Cod Bay. Longtime Eastham resident George Rongner told the story to the Henry Beston Society in 2005:

> *Hoppy craftily led them fairly close to shore on a dark night, talked them into anchoring until daylight, and when daylight arrived, the vessel was on its side, aground as the tide receded and left the area bare of water. Easthamers simply walked out, imprisoned the English sailors and marched them to the Eastham tavern, later to be the home of the Hurds.*

Alice Lowe and Matilda Smart re-created the rest of the story for the Eastham Historical Society. According to Smart, "Edward C. Clark and George Collins were on the shore during the episode and helped march the British to Crosby's Tavern, where other fellow townsmen Timothy Cole, Obed Sparrow, Jabez Rich, Squire Harding Knowles and Peter Walker, the blacksmith, happened to be." The British then threatened to shell Eastham, prompting the release of the soldiers. In addition, the British ordered the town to pay the sum of $1,200 and return Mayo as prisoner. The money was paid, but Mayo refused and went into hiding in the local swampland, avoiding capture. Lowe noted that Mayo "took great delight in showing his grandchildren the hiding place many years later."

11
Some Eastham Washashores

What utter loneliness and terror he must have felt as he lay helplessly dreading the battering he knew would come with the return of the tide; how he must have wished the sailors had not tied him so securely to the mast; and what a feeling of gratitude he must have had for the man who brought that lonely terror to an end.
—*Alice A. Lowe,* Nauset on Cape Cod

The Fulcher Lineage

While many of Eastham descendants arrived here by the *Mayflower* or one of the other earlier Plymouth-bound vessels, there's one family that began its lineage here as a true washashore.

Freeman Doane Mayo was scanning Nauset Beach one day in April 1852 with the intent of finding debris from the shipwreck of the British brig *Margaret*, which ran aground and had broken up. What he never counted on was finding someone who would start a long line of descendants that would stretch all across the Lower Cape.

In the surf, Mayo spotted a mast from the *Margaret*, out of Hartlepool, England—and on that mast was none other than a fourteen-year-old boy named John Fulcher.

Just after 3:00 a.m. that morning, the *Margaret* lost its bearings in the fog off the Cape and piled on Nauset Beach. Fulcher, an apprentice on board

the vessel, grabbed the ship's cat, tucked it into his shirt and managed to latch on to the mast and get to shore.

Mayo freed the child, wrapped him in his coat and warmed and fed him by his fireside. When the time came for the *Margaret*'s survivors to return to England, Fulcher had other ideas. The English runaway decided to stay put. For a few weeks, he lived with Mayo and his family, which included two sons who were "young captains of deep sea merchantmen," according to Edgar Spears's compilation, "Family History of John Fulcher and Josephine Helena (Doane) Fulcher."

Fulcher, born in Great Yarmouth, England, on June 7, 1837, went to live with Captain Samuel Knowles, owner and operator of the old windmill, and his family. He worked at the farm of Ezekiel Doane for several years and married his daughter, Josephine Helena Doane, on December 7, 1859. The couple had ten children: Dawson, Mary, Alfred, Zeke, Fred, Josephine, Sarah, Louis, Obed and John Jr., who ran the Eastham Windmill for a time and was the last man to operate the old machinery.

He continued to follow the sea in the mackerel, oyster and coasting trades but finally settled on a farm and purchased the farmhouse from his in-laws for $650 in July 1867. He later acquired many other lots of surrounding land, eventually increasing the first half-acre lot to one hundred acres. In April 1868, Fulcher became a U.S. citizen. *Pratt's History of Eastham* noted that most of John Fulcher's farmlands were in the same boundaries as those lands that were granted to Governor Thomas Prence.

After the French Cable Station was built in North Eastham, Fulcher became friendly with the Englishmen who operated it, and with their encouragement, he made a visit to England, where he located his family in Great Yarmouth.

Almost one hundred years after the wreck of the *Margaret*, one of Fulcher's grandsons, Ezekiel Fulcher Jr., was chief boatswain's mate of the Coast Guard crew that won the boat-capsizing drill by setting a record of thirty-one seconds in overturning and righting their lifeboat at the 152nd anniversary of the establishment of the Coast Guard service held at the Charles River Esplanade in Boston.

Obed Fulcher lived at the farm following his parents' passing. Today, there are Fulchers across the Lower Cape, all descendants of John Fulcher. Spears noted, referring to the tune "Old MacDonald," "As the old refrain goes: Old John Fulcher came ashore…here a Fulcher, there a Fulcher, everywhere a Fulcher, Fulcher. Obed Fulcher had a farm…"

The *S-19*

While walking the shores of the Outer Cape, it's not unusual to encounter all sorts of flotsam, jetsam or other debris that's washed up on the sand. Usually, it's something like a lobster buoy or a life preserver. Sometimes you'll even find half a stairway, a piece of furniture or even a propane tank. However, nothing might be more unusual than what washed up on the beach near the Nauset Harbor inlet on January 13, 1925.

The USS *S-19* (SS-124), bound for New London, Connecticut, from the Portsmouth Navy Yard with a crew of forty, found itself in this predicament thanks to thick fog, strong winds and heavy seas. Try as they might, two Coast Guard cutters, the *Tampa* and the *Acushnet*, were unable to get a line to the sub, which had settled seven feet in the loose sand.

Led by Captain Abbott Walker of the Nauset Coast Guard Station in Eastham, a rescue from land was attempted. Walker, along with Wilbur Chase, Russell Taylor, Kenneth Young, Henry Daniels, William Eldredge and Zenas Adams of the Nauset station, launched a boat and came to within one hundred feet of the sub before being capsized by the heavy surf. Another attempt resulted in the boat being smashed, but all of the Coast Guardsmen were fortunate enough to make it back to shore.

"It was miraculous that all reached the shore, for some of the men clung to the overturned boat forty-five minutes before being rescued from the water," was how Alice Lowe described the situation. "They were taken to the Hopkins gunning camp where a warm fire and blankets soon revived them."

The next day, Walker and company tried again in a different boat, and the Nauset commanding officer was swept overboard, narrowly escaping death before being rescued by his men. Finally, a team effort by the Nauset and Cahoon Hollow Coast Guard Stations was successful in the quest to free the crew from the sub, nearly two days after it washed ashore. "Needless to say, the Nauset crew received a 'well done' from a grateful Navy Department," wrote Mike Maynard of the Coast Guard Heritage Museum in 2012.

It was reported that the *S-19*, built in 1921 at a cost of $4 million, was finally freed from its watery prison by U.S. Navy tugs and Coast Guard cutters in March. However, George C. Reeser reported to the Eastham Historical Society that was not the case:

> *After a few weeks, Dan Gould, an Orleans lobsterman, did succeed in freeing the vessel by running lines from two heavy anchors space some distance apart to a snatch block through which a line was run from the sub,*

and then to a stationary engine on the beach. In this manner, the engine on shore kept a steady pull on the sub. The tug also had a line to the sub. Gould was never given any recognition by the Navy.

According to Ralph Lindwood Snow, Walker knew that the launch could not get through and said so. The message sent from the submarine by blinker read "send boat," but it was badly obscured due to poor weather conditions. After the rescue, it was learned that the message sent was "Do not send boat!"

The navigator of the sub was cleared of any wrongdoing by a board of inquiry. He was later navigator of a squadron of destroyers lost at Point Loma, California, around 1934 or 1935. The sub was repaired in Boston and returned to operations until October 1930, when it was sent to Pearl Harbor in Hawaii. The vessel was decommissioned in 1934 and struck from the Naval Register in 1936. In accordance with the London Naval Treaty, it was given a standard "burial at sea" in December 1938.

12
KEEPERS OF THE CAPE CHRONICLES

A noble world, and one is glad that it once touched the imagination of the obstinate and unique genius from whom stems the great tradition of nature writing in America.
—Henry Beston on Henry David Thoreau, 1951

Cape Cod has long been a haven for literary legends over the years, particularly on the outer reaches of the peninsula. When one sets out on the ocean side of Eastham, three writers stand out: Henry David Thoreau, Wyman Richardson and Henry Beston.

Out of the three, Thoreau is undoubtedly the most recognized and quoted. His trips to the Cape during the mid-1800s resulted in a series of magazine articles that were published posthumously as *Cape Cod* in 1865. While his journeys covered one end of the Cape to the other, Eastham was a significant stop along the way. "When he descended the earth-cliff at some point a little to the north of Eastham village and its 'salt pond,' Thoreau found what he had come to see," wrote Beston in the introduction to *Cape Cod* in 1951. "There lay the unbroken miles which had stirred his interest when he had seen them on the map, there stood the outer beach."

Even in the mid-1800s, well before the U.S. Life-Saving Service came into being, shipwrecks were a frequent occurrence on Massachusetts beaches. While the Cape certainly had its share, Thoreau got his first taste of a shipwreck while passing through Cohasset. "*Cape Cod* starts off with the Cohasset shipwreck and how it made an impression on him," noted

A Brief History of Eastham

Henry David Thoreau passed through Eastham during his outer beach walks, chronicled in his book *Cape Cod*. *Library of Congress.*

William Burke, historian for the Cape Cod National Seashore, in 2016. "Even before he got to the Cape, he kind of got this taste of what was to come about shipwrecks. It's a very well-written description and pretty grim. It's interesting on how that pops right up in the beginning."

During the nineteenth century and first half of the twentieth century, Eastham was a barren, treeless landscape. Thoreau observed that a solitary traveler off in the distance "loomed like a giant," and "to an inlander, the Cape landscape is a constant mirage." On his way to the Three Sisters lighthouses, he wrote that they "had found ourselves at once on apparently boundless plain, without a tree or a fence, or, with one or two exceptions, a house in sight. Instead of fence, the earth was sometimes thrown up into a slight ridge."

Thoreau also left behind a piece of writing, "Outfit for an Excursion," in Eastham that was uncovered nearly a century later by Flora Knowles and published in the *Cape Codder* on August 21, 1947. The piece, which included several misspelled words and missing punctuation, was written during a visit to Noah Doane's house in 1849. "I found it very interesting reading—especially the ending, the cost for the outfit at twenty dollars, compared to our present costs," Knowles told the *Cape Codder*. "Today we have to pay that amount, or nearly that, for two used shirts."

Nearly three decades after Thoreau's passing, the stage was being set for another literary luminary to make his mark on Eastham. Dr. Maurice Howe Richardson, the first surgeon-in-chief of Massachusetts General Hospital, and two family members were in search of hunting grounds for shorebirds and ducks. Ipswich and Chatham were considered before the doctor was introduced to an area near Little Creek. For $650, the family purchased an old half-Cape house that would become the base for the book *The House on Nauset Marsh*, in 1947. Maurice Richardson's son, Dr. Wyman Richardson, chronicled the life at the marsh-side farmhouse: "You can go to Eastham, on outer Cape Cod, and live in the little old Farm House at the drop of a hat," he wrote.

Wyman Richardson, who lived in Newton, had a family practice on Beacon Street in Boston and taught hematology at Harvard Medical School

Wyman Richardson, author of *The House on Nauset Marsh*, 1940s. *Cape Cod National Seashore.*

and Massachusetts General Hospital. His escape from everyday life was Eastham, where the occasional "Do Nothing Day" was permitted. It's also believed that Richardson spent many late nights writing his articles about the house, which were also published in the *Atlantic*, as a diversion to the pain he was experiencing from illness.

The Richardson family still owns the Eastham property. One of its residents was Elliot Richardson, Wyman's nephew and a political figure who

held several positions in the Nixon administration. Though still privately owned, the house is now located within the boundaries of the Cape Cod National Seashore. Both the Richardson house and boathouse are visible from the Nauset Marsh Trail.

The Richardsons also played a small role in introducing another literary icon to Eastham and the Outer Beach. According to Marie Sheahan, a niece of Henry Beston, Maurice Richardson was a professional colleague of Dr. George Sheahan, a Quincy surgeon who was also Beston's older brother. Richardson invited Dr. Sheahan and his younger brother to the Eastham farmhouse during Beston's high school and college years.

Beston, who was born Henry Sheahan in Quincy on June 1, 1888, was a volunteer ambulance driver and stretcher bearer for the American Field Service in France from 1915 to 1916. His work took him into the middle of some of the war's bloodiest battles, including the Battle of Verdun. Under his given name, Beston wrote two books about his war experiences, followed by two books of fairy tales written under his newly adopted surname of Beston. As he continued to find his way as a writer, the war experiences haunted him considerably.

Henry Beston was a good friend to the Coast Guardsmen of the Nauset Station and was given a summer dress uniform, which he wore proudly. *Henry Beston Society.*

In 1923, Beston took an assignment for the *World's Work* magazine that brought him back to Cape Cod. He wrote an article, "The Wardens of Cape Cod," about the Coast Guardsmen of the Outer Cape, an effort that eventually led him to *The Outermost House*. While his earlier visits to the Cape were brief, this trip made him a Cape Codder at heart forever. Beston visited several of the Coast Guard stations of the Outer Cape, including Race Point, Cahoon's Hollow, Monomoy and Nauset, which oversees the beach where he decided to build the beach cottage that he called the Fo'castle.

On the Outer Beach of Cape Cod

According to Daniel G. Payne, author of the Beston biography *Orion on the Dunes*, the effects of living in outer nature began to have a healing effect on Beston:

> *This was the era of the lost generation. People were losing faith in their institutions—government, religion, education—and started to think, "Maybe we're headed down the wrong path." Well, OK, but what do you do then? And as Henry comes out to the Cape and starts reveling in nature and being heartened by people living close to nature, he starts seeing his counterweight to industrial civilization.*

Beston befriended many in town. He often stopped by the Eastham Schoolhouse, where the principal, Otto Nickerson, invited him to tell stories of his extensive travels to the older children. Before the Fo'castle was built by local carpenter Harvey Moore in 1925, Beston stayed at the cottage on the Sullivan property, located across the road from the Salt Pond, and often joined them for Sunday dinner. George Rongner, whose father, Yngve, was

Henry Beston stands on the front porch of the Fo'castle, the small cottage that was the base for his book *The Outermost House* in this 1925 photograph taken by Yngve Rongner of the Nauset Coast Guard Station. *Henry Beston Society.*

A Brief History of Eastham

Yngve Rongner of the Nauset Coast Guard station, is flanked by his wife, Selma, and son, George, in this photo taken by Henry Beston in front of the Fo'castle in 1925. Beston and the Rongners often visited each other. *Henry Beston Society.*

The Fo'castle, the base for Henry Beston's book *The Outermost House*, as it looked in the 1970s. Photo by Nan Turner Waldron. *Henry Beston Society.*

a Coast Guard surfman, idolized the towering writer from Quincy and often referred to him as his "quasi-uncle."

Beston left the beach in 1928 and returned to Quincy, eventually marrying the writer Elizabeth Coatsworth in 1929, before moving to Maine in 1930. Over the years, his Cape Cod visits became less and less frequent. His book *The Outermost House* sold slowly at first, but it eventually became known as a nature classic.

According to George Palmer of the National Park Service, when survey teams from the National Park Service visited the Outer Cape during the 1950s, *The Outermost House* was used in the reports to make the case for the area to be set aside. "The book…was like a validation of what we were up to," said Jonathan Moore, a legislative assistant to Senator Leverett Saltonstall, in a 2011 interview with the Henry Beston Society. "Elliott Richardson and I used to talk about *The Outermost House* a lot, and I know that [Senator Leverett] Saltonstall mentioned it in the course of work to get the legislation established."

In 1964, the Fo'castle was designated as a National Literary Landmark, and Beston, whose health was declining, visited Coast Guard Beach one last time for a special ceremony that his family dubbed "The Coronation." The Fo'castle was eventually washed away during a massive winter storm on February 6, 1978.

"You've described our great beach here, and the ocean that comes in upon it, as no one else ever could or ever will," stated Massachusetts governor Endicott Peabody during the ceremony, which included Kurt Vonnegut and a young Robert Finch in the audience. "*The Outermost House*, as a testament, has had immeasurable influence. Your book is one of the reasons that the Cape Cod National Seashore exists today, to be protect the beach and many acres around it, for future generations."

13
Eastham, D.C.

While nearly five hundred miles separate Eastham from the nation's capitol, Washington, D.C., has crossed paths with the land of the Nausets on a couple of occasions—first during the Depression era, then again in the 1970s.

FDR and the Eastham Stamp Club

While the Roosevelts are best known for their connections to New York, both presidents are also tied to the Outer Cape. In 1910, Theodore Roosevelt was at the groundbreaking ceremony for the Pilgrim Monument in Provincetown. Twenty-three years later, Franklin D. Roosevelt became an official member of the Eastham Haymow Stamp Club.

The club consisted of seven Eastham boys—club president George Rongner; Don, Fenton and Robert Sparrow; William and Robert Watson; Kenneth Mayo—and the club's official mascot, Skippy, the Sparrows' water spaniel. On a rainy fall afternoon, the boys drafted a letter to Roosevelt, complete with an official membership card. "We knew that President Roosevelt was a stamp collector, and we thought that he was worthy of membership in our club," Rongner recalled in a 1981 interview with the Eastham Historical Society. "We made our own cards from old cereal boxes. We were quite surprised that, within a week, we received a reply from the

White House, written and signed by his private secretary, Miss LeHand, that the president was delighted that our thoughts were with him."

"The seven Eastham grammar school lads, ranging in age from ten to fifteen, are pretty proud of their club now that President Roosevelt has decided to join," proclaimed the April 1, 1934 edition of the *Boston Globe*.

Roosevelt devoted daily time to his hobby and once said, "I owe my life to my hobbies—especially stamp collecting." His son, James Roosevelt, recalled, "I have vivid memories of Father sitting at his desk when he had a half hour or hour with no appointments…with his stamp books and an expression of complete relaxation and enjoyment on his face."

The club was named for its first meeting place, the Mayo family's haymow, but in a few weeks, Dan Sparrow, the father of three brothers, cleared out an unused chicken coop behind his garage. "We narrowly escaped being the Eastham Chicken Coop Stamp Club," Don Sparrow recalled in 1999.

During the dark days of the Depression, the tale of FDR becoming an official member of this tiny Cape Cod club "became the human interest story of the day," Rongner recalled. "People were looking for the lighter side of life, and newspapers sent reporters and photographers to take our pictures. People around the country picked up the story, and it was on radio broadcasts. We received letter after letter filled with stamps from people who were stamp collectors."

The club lasted for about two years, but interest began to decline. "I think the letter had something to do with it," Rongner said. "We all wanted it, and then we weren't having fun anymore."

The VIP House

During the 1970s, the Nixon administration found itself in the news frequently, and not for reasons that it particularly wanted. One of those instances was John Ehrlichman and the covert White House Special Investigations Unit known as the "Plumbers," which was organized to stop certain information leaks in the federal government.

According to the July 4, 1974 edition of the *Cape Codder*, Ehrlichman "was taking a break from the rigors of 1971" in what the Cape Cod National Seashore referred to as "E 187," or the "VIP House," a cottage located on the bluff just north of the old Nauset Coast Guard Station

that was purchased by the National Park Service in 1964 from H. Craigin Barlett. According to the *Cape Codder*, Ehrlichman, on one of his short stays at the cottage, was phoning in his orders to the Plumbers, who were working on what came to be known as the "Ellsberg Caper." The *Cape Codder* reported, "Ben Bean, the chief ranger, remembers that Ehrlichman was a visitor, because afterward, when Watergate broke open, the FBI came down and questioned him about it."

Many other government figures, cabinet and Congressional members paid token rates, up to twenty-five dollars, to stay there. One or two other national parks had VIP Houses, and it was customary for dignitaries to use them. Other government figures signed in to the house's log included Jeb Stuart Magruder, Senator Robert Packwood, Senator Richard Schweiker, White House special assistant David Packard, Donald Rumsfeld, "special assistant to the President" Edwin Harper and Congressman Jack Edwards.

14
Gateway to the Cape Cod National Seashore

The time must come when this coast will be a place of resort for those New-Englanders who really wish to visit the seaside.
—Henry David Thoreau, *Cape Cod*

One day in 1905, Dr. Herbert Howard and a visitor, Dr. L. Thomas Hopkins, were sitting on the former's porch in Truro, gazing over the scenic Atlantic Ocean and land. As is often the case with a view like this, caring for the beauty and splendor of this corner of the world became the topic of conversation.

"All of this area should be taken over and preserved by the state or federal government to prevent private development," Howard—a nationally known educator and, at the time, the director of Massachusetts General Hospital—said to Hopkins.

This exchange, noted by former managing editor of the *Cape Codder* Francis Burling in his 1977 book, *The Birth of the Cape Cod National Seashore*, proved to be prophetic, even though it would take another fifty-six years to come to fruition. At the time of this meeting, it would still be another eleven years before there was even a National Park Service.

The park service was officially created on August 25, 1916, signed into law by President Woodrow Wilson through the National Park Service Organic Act. Even though there were national parks such as Yosemite and Yellowstone already in existence, they were under the umbrella of the U.S. Department of the Interior and considered low priority. The

establishment of the National Park Service gave these natural shrines their very own agency.

It would be another two decades before serious thought was even given to Cape Cod achieving National Park status. In 1937, Cape Hatteras in North Carolina became the first national seashore. That same year, as James O'Connell noted in his book *Becoming Cape Cod: Creating a Seaside Resort*, the *Cape Cod Beacon*, a vacation magazine, had a similar thought to the one Dr. Howard had over thirty years earlier. "One thing we thought of is to have the federal government set aside a section of the Cape as a national park, which would prevent further commercialization by dollar-seeking individuals," the *Beacon* wrote.

The *Beacon* wasn't the only source of support for a seashore park on Cape Cod in those days. Conrad Wirth was a landscape architect responsible for the newly formed NPS unit of Civilian Conservation Corps (CCC) in the 1930s (a product of President Franklin D. Roosevelt's New Deal). Wirth secured funding for a study of possible national seashore sites along the East Coast. In 1939, NPS consultant Thomas H. Desmond proposed that a national seashore extending from Duxbury to Provincetown be considered: "The upper arm of the Cape from Eastham to Provincetown is largely undeveloped, outside of a few small villages. It is very little occupied, but it is only a question of a short time before it will become exploited unless it can be saved by public purchase."

The proposal had its supporters, but not in Washington. The Cape was considered to be "too hard a job to tangle with" at the time. Then came World War II, which the United States entered in December 1941, following the attack on Pearl Harbor. By 1942, funding for the National Park Service had become a low priority. The department became a victim of funding cuts, and the budgets remained thin for several years after the war ended.

By the early 1950s, funding still hadn't been restored, and criticism over neglect of the national parks mounted. A stinging indictment by essayist Bernard DeVoto in *Harper's Magazine* called for the parks to be closed until appropriate funding became available. Enter Wirth, who became director of the National Park Service in 1951. As the United States was emerging from the dark years of the Great Depression and World War II, Americans found themselves looking for new adventures. New roads were being built, such as Route 6 on Cape Cod. By 1956, backed by enthusiastic support from President Dwight D. Eisenhower and Congress (which kicked in over $1 billion in appropriations), Wirth and his charges responded with Mission

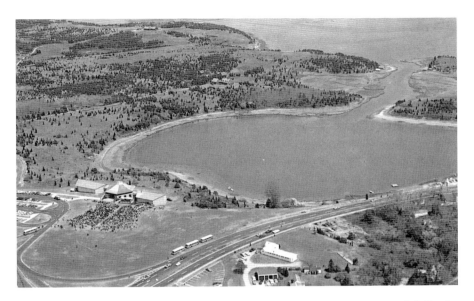

An aerial view of Route 6, the Salt Pond and the Cape Cod National Seashore's Salt Pond Visitors Center. *Eastham Historical Society.*

66. The goal of the ten-year program was to upgrade facilities, staffing and resource management throughout the system by the fiftieth anniversary of the National Park Service in 1966.

Two years before Mission 66 became official, a new survey evaluating the coastlines between Canada and Mexico was conducted. Unlike the 1930s evaluation, "Great Beach, Cape Cod, Massachusetts…came out A-1" in the new study. The Cape "is believed to be of national significance," and "the geology of the area is interesting and the history outstanding," the report stated.

Following a meeting between Massachusetts senator Edward C. Stone and the *Cape Codder*'s publisher, Malcolm Hobbs, at the newspaper's Orleans office, the November 1, 1956 edition of the *Cape Codder* broke the story that National Park Service was moving forward with plans for a national seashore. The Seashore Recreation Survey team was taking an inventory of possible sites for new park and recreational areas. The undeveloped—and untaxed—land along the Outer Beach, including Eastham, would be ideal for this.

Still, there were more evaluations to be done before Cape Cod could even be considered for this new movement. Wirth dispensed a NPS survey team

to the Cape for further evaluation. The report, "Cape Cod: A Proposed National Seashore Investigation Report," was released by the National Park Service and the Department of the Interior in 1959.

Massachusetts Representatives Thomas "Tip" O'Neill, Philip J. Philbin and Edward Boland filed the first bills for the creation of the Cape Cod National Seashore in 1957. The final proposals were pushed through by Senators John F. Kennedy and Leverett Saltonstall and Representative Hastings Keith. Legislative assistants Fred Holborn, David Martin and Jonathan Moore were "the heroes who most clearly emerge from this account," wrote Elliot Richardson in the introduction of Burling's book.

Across the Outer Cape, there were pockets of resistance to the proposed park. In the November 8, 1956 edition of the *Cape Codder*, Eastham selectman Maurice Wiley said:

> *I would like to give the proposal more study, but I do feel that some of the natural beauty of part of Cape Cod should be saved for future generations. Look at the marvelous job the state is doing in rescuing the Pilgrim Springs area for use as a park and as a beautiful spot to which people will come hundreds of years from now. We can't just think all the time of the money we can make today. We must also think of those who will come after us.*

U.S. Interior Secretary Stewart Udall echoed Wiley's sentiments during a dedication ceremony for the park a decade later. "Our economic standard of living rises but our environmental standard of living…our access to nature and respect for it…deteriorates," Udall said, according to the *Cape Codder*.

In 1964, George Palmer, a National Park Service regional manager in Philadelphia, outlined the evaluation process used for the Cape in the 1950s:

> *As we go into any park area to study the desirability of establishing or at least recommending that Congress establish it, we look at several things. First of all, we look at the geography and the geology of it, we look at the natural history, the plant life, the animal life, we look at its human history, the people who live there and what use they've made of the lands, and then we look to what use people are coming in now may make of the area, what it may mean to them, why it would be a unique experience, and why it's worth saving for our children and our grandchildren.*

For the next two years, the well-documented views about the proposed park from Cape Codders were vented from Provincetown to Chatham.

Public disputes over the park became heated. After all, this was the first time that a national park was to be established in a residential area. The most persistent and vehement voices against the park, according to the March 12, 1959 edition of the *Cape Codder*, were members of the Eastham Citizens Committee, formed in April 1958 specifically to oppose federal or state land taking and "conserve Eastham for the people of Eastham." Conrad Wirth spoke at the March 6 meeting in Eastham, which drew residents from Eastham and other towns, many of who were hostile.

Blending the public and private sectors was no easy task. In *The Birth of the Cape Cod National Seashore*, Francis Burling cited a 1966 report on Sleeping Bear Dunes National Lakeshore: "The Cape Cod bill had broken new conservation ground through its attempt to harmonize existing private developments with long-term conservation and by its revolutionary procedure of authorizing federal funds to purchase those private lands vital to public recreation and resource protection."

"Cape Cod was the first seashore or park of any size (nationally) that was established within an area was already developed," Moore noted in a 2011 interview. "Hatteras had already been established, but it wasn't developed."

Boundaries and what would and wouldn't be included in the park were drawn and redrawn again and again. One of those battlegrounds was at Fort Hill, where Champlain landed nearly three and a half centuries earlier. The scenic vista wasn't in a lot of the proposals for preservation, as the Mel-Con development company bought Fort Hill in 1960 and divided it into thirty-three lots.

A Congressional subcommittee—chaired by Senator Alan Bible of Nevada and consisting of Senators Hiram Fong of Hawaii and Benjamin Smith of Massachusetts, Representative Hastings Keith of the Bay State, National Park Service regional director Ronald Lee, Massachusetts National Resources commissioner Charles H.W. Foster and legislative assistants Moore and Milton Gwirtzman—was taken on a helicopter tour of the region. The helicopter landed at Fort Hill, and it was here that Moore "played a significant role in alerting the press and Cape Codders to the threat of development," according to a 2011 interview with WCAI-FM.

In interviews with both WCAI and the Henry Beston Society, Moore told of how, after the helicopter landed, Keith began a pitch to keep Fort Hill out of the park. Moore pointed out the stakes that were set up for a subdivision, then stated that the public would never be able to see the view, "because the houses that you want to build there will not allow you to see through them." Moore said that he did not intend to publicly challenge Keith, but his

irreverence was well reported in the press. Burling quoted Moore as saying, "Later Senator Bible leaned over in the helicopter and said to me, 'That decided it for me!'"

While the Cape Cod National Seashore legislation was being shuffled through Congress, Van Ness Bates, a Boston developer, was putting together some big plans for the Outer Cape. Bates envisioned a Pilgrims Crossing bridge from Plymouth to Provincetown and the President Cleveland Crossing, an option for the Buzzards Bay area that would cross the southern entrance of the Cape Cod Canal. The alternative routes were the Gosnold Crossing and Cameron Forbes Crossing projects, designed to accommodate traffic from the New York City area. These routes would have run from the Wesport-Dartmouth area, along the Elizabeth Islands chain and up to Route 28 in Falmouth.

On the drawing board for the Outer Cape were two parkways to run along the bay and ocean shorelines between Truro and Eastham. The beginning of the Ocean View Parkway was to the northwest of Coast Guard Beach in Eastham and—"keeping our alignment as high and as scenic as possible"—proceeded north to Cable Road in North Eastham, "whence a coastal segment northward of Nauset Light already exists for more than a mile. This segment is a propitious validation of the coastal parkway principle we advocate." The parkway would continue north and connect with Ocean View Drive at Lecount Hollow Road in Wellfleet before ending near High Head in North Truro.

The plans didn't go far. The developer predicted that following through on his intentions would bring "consternation and incredulity to many." Among the incredulous Outer Capers was Provincetown writer Josephine Del Deo and artist Ross Moffett, whose resistance helped to put an end to any further moves from Bates.

A Mission 66 hallmark was the visitors center, two of which were constructed for the Cape Cod National Seashore: one in Provincetown and the main center at Eastham's Salt Pond, a site that was once called home by both the Eastham Windmill and Reverend Samuel Treat. The Salt Pond center was built at a cost of $370,000.

John F. Kennedy, who as a senator was one of the earliest sponsors of the Cape Cod National Seashore bill, along with Keith and Saltonstall, became president in January 1961 and signed the bill, Public Law 87-126, into law on August 7, 1961. On May 25, 1966, Establishment Day ceremonies were held at the Salt Pond Visitors Center, with Saltonstall, Keith, Massachusetts governor John Volpe, Massachusetts senator Edward Kennedy and

Secretary of the Interior Stewart Udall all in attendance. National Park Service regional director Lon Garrison was the master of ceremonies. Five days earlier, rumors were flying that President Lyndon Johnson and Vice President Hubert Humphrey might be attending, but it didn't happen.

As Udall stated, according to the *Cape Cod Standard-Times*, "Beyond the noise and the asphalt and the ugly architecture…we yearn to see white winds on morning air, and, in the afternoon, the shadows cast by the doorway of history. The Cape Cod National Seashore is, in a very real sense, a pioneer park."

Today, nearly four million visitors make their way to the Cape Cod National Seashore. Most of them will pass through Eastham, the "Gateway to the Cape Cod National Seashore." As Henry Beston wrote in *The Outermost House*, after describing several of its outstanding geographic features that are now part of the historic seashore park, "This is Eastham, this is the Outer Cape."

15
Celebrating Eastham's Past

May the [Eastham tercentenary celebration] *prosper mightily and be worthy both of the town between the seas and of those who in all these thrice hundred years have loved it with such pride and depth of feeling.*
—*Henry Beston,* Introduction to Eastham, Massachusetts: 1651–1951

The history of Eastham, formerly known as Nauset, reaches back some four hundred years, and that's only counting the years since the earliest European settlers first set foot here. The residents here, some of whom include descendants of the First Comers from the *Mayflower*, take their history seriously. Since 1977, the weekend after Labor Day is set aside for Windmill Weekend festivities. The Windmill and Nauset Light draw nonstop visitors during the summer months, and the Eastham Historical Society keeps itself busy in two locations: the Swift-Daley House Museum and the 1869 Schoolhouse Museum.

Landmark anniversaries are also a reason for celebration in Eastham. The town's 350th anniversary bash in 2001 was one for the ages. When the Cape Cod National Seashore had its 50th birthday in 2011, there was one event after another at the Salt Pond Visitors Center. The same went for the National Park Service's 100th birthday in 2016.

One of the biggest parties Eastham ever threw happened in 1951, when the town held its tercentenary celebration. Even though the town was founded in 1644 as Nauset, it wasn't until 1651 that it became Eastham. When the town turned three hundred, its residents were ready to celebrate.

Although the town celebrated throughout the year, the highlights came during the week of August 19–25. The town's tercentenary celebration was highlighted by thousands of people attending a huge parade, a clambake, a historic pageant and a massive square dance on the town's famous Windmill Green.

On hand for the party was none other than Mayor Walter E. Hereford of East Ham, England, the Outer Cape haven's sister city. The mayor and his wife were front and center during the August 22 parade. "Thousands Witness Parade at Eastham" was the front-page headline of the August 23, 1951 edition of the *Cape Cod Standard-Times*: "Thousands of persons lined both sides of G.A.R. Highway for two miles yesterday afternoon and saw one of the largest parades ever held on Cape Cod as it wended its way through the center of Eastham. There were nearly 100 floats, miscellaneous entries and marching units."

The procession started at the Eastham Schoolhouse, located at the western end of Nauset Road, and moved down the highway past the town hall and bandstand to Governor Prence Road. Prizes were awarded to several of the floats. "The Vikings Return to Cape Cod" took honors for first place.

A few days later, the Tercentenary Pageant featured a reenactment of the historic First Encounter between the Pilgrims and natives on the very beach where it happened 331 years earlier. The eight-episode production was written and directed by Lewis W. Miller, formerly with the Brewster Summer Theatre, and featured Harry W. Collins as Myles Standish, William James as Chief Aspinet, Ralph L. Rogers as Governor William Bradford, Maurice Wiley as Governor Thomas Prence, Luther P. Smith as Reverend John Mayo and George Howard as Reverend Samuel Treat, along with dozens of others in supporting roles.

Chairs were set up on the beach and in the parking lot for 1,200 people, but nearly 2,000 were in attendance at "the locality which heard the war-whoops of the Nauset Indians when they attacked Captain Myles Standish and a party of Pilgrims from the *Mayflower*," according to the *Cape Cod Standard-Times*. Earlier in the week, the secretary of the Commonwealth of Massachusetts, Edward J. Cronin, presented Maurice Wiley, chairman of the Eastham Board of Selectmen, with a copy of the original deed that the Nausets gave to Governor William Bradford.

Saturday, August 25 kicked off with the Real Old-Fashioned Rock Clambake on the grounds of town hall, where, for $3.50 per plate, hundreds dined on a menu of clam chowder, clams, fish, lobsters, hot

dogs, sweet potatoes, onions, sweet corn, brown bread, melted butter, coffee and watermelon.

That night, at 8:00 p.m., the Windmill Green was the scene for the Open Air Old-Fashioned Square Dance, which was planned and produced by well-known caller Dick Anderson, assisted by Jay Schofield of Eastham. Music was provided by Mel Von and his orchestra. According to the report of the Eastham Tercentenary Committee:

> *Over 2,000 people gathered to dance and also watch a scene of rare beauty. Searchlights placed at intervals flooded the mill and lawn with an almost daylight brilliancy. The secret of sets made up of young folks and old in gay attire gracefully executing the various figures to orchestral music and under guidance of skilled "callers" provided a picture of matchless delight.*
>
> *A picturesque feature of the evening was the Grand March. Led by Mayor and Mayoress Hereford of East Ham, England, hundreds of couples formed a procession of jolly marchers and did a snake dance about the grounds lined by applauding onlookers.*

The mayor and his wife were also presented with the latch string of Eastham, an old custom, by Selectman Wiley. "That latch string…will be very highly prized and treasured," Mayor Hereford said. "To be here on the tercentenary celebration of Eastham is indeed a rare and very great privilege."

"A rare and great privilege" has often been the mantra of those who have called Eastham home. As Henry Beston concluded in his introduction to *Eastham, Massachusetts: 1651–1951*, "Out of Eastham has come something which has given strength, color, romance, and depth of feeling to the whole American adventure."

Bibliography

Unpublished Manuscripts and Collections

Archives for Chapel in the Pines, Eastham Historical Society, Eastham, Mass.
"Eastham Tercentenary Celebration." Eastham Historical Society.
Nickerson, W. Sears. "Some Lower Cape Indians." 1933. Sturgis Library Archives Genealogy and Personal Manuscripts Collection. Sturgis Library, Barnstable, Massachusetts.
Peterson, Ron. "The Lifesaving Legacy of Orleans." For the Orleans Historical Society, Orleans, Massachusetts.
Spear, Edgar W., comp. "Family History of John Fulcher and Josephine Helena (Doane) Fulcher." Eastham Historical Society, Eastham, Massachusetts.

Reports

"The Astonishing Voyage of the Northern Light." New England Historical Society.
Gilmore, Andrea M. "Historic Structure Report, Captain Edward Penniman House, Cape Cod National Seashore." 1985.
Grover, Kathryn. "Automobile-Age Tourism in Eastham, 1900–1960: A Context Statement." Eastham Historic Properties Survey Project, August 2005.

Bibliography

Kasparian, Lance. "U.S. Coast Guard Nauset Station Dwelling and Boathouse Historic Structure Report." Cape Cod National Seashore, Historic Architecture Program/Northeast Region, National Park Service, January 2008.

Massachusetts Historical Commission file on the Sullivan house. Eastham, Massachusetts, March 2001.

"Old Comers and Purchasers in Early Eastham History." Eastham Historical Society.

Portland bodies washed ashore on Eastham, 27-28-29 November 1898. From records, Eastham Town Records of Deaths, George J. Dill, registrar. Copied for Albert E. Snow by Howard Willis Quinn, 1966.

Snow, Commander Albert E., USNR (Ret.). Account of the *Portland* presented to Eastham Historical Society, May 1969.

"Thomas Paine / Eastham Land Records, 1650–1745." Robert P. Carlson, Eastham Public Library, Eastham, Massachusetts.

"Town of Eastham Massachusetts Eastham Historic Properties Survey." 1995. Massachusetts Historical Commission, Boston, Massachusetts.

Van Ness Bates and Associates. "The Cape and the Park." U.S. Congress. December 7, 1960. Boston, Massachusetts.

Interviews and Events

Boonisar, Richard. Interview with the author. South Dennis, Massachusetts, September and October 2015.

Burke, William, Cape Cod National Seashore historian. Interview with the author, June 2016.

Collins, Bernard. Interview with Tales of Cape Cod, 1977.

Collins, Kenelm. Speech to the Eastham Historical Society at Eastham Methodist Church, October 26, 1997.

Cummings, Prescott "Bud." Interview by Don Sparrow. Eastham Historical Society, July 9, 1983.

Greaney, Dianne. Interview with the author. Orleans Historical Society. July 2015.

Jewell, Frederick. Interview by Vivian and Ralph Andrist. Eastham Historical Society, March 9, 1981.

Moore, Jonathan. Interview with the author. Henry Beston Society, July 2011.

———. Interview with WCAI-FM, 2011.

Bibliography

Nickerson, Arthur. Interview by David Eagles. Eastham Historical Society, January 13, 1994.

———. Interview by Vivian Andrist. Eastham Historical Society, May 12, 1982.

Nickerson, Otto. Interview by Vivian and Ralph Andrist. Eastham Historical Society, November 25, 1980.

Owens, Jim. Interview by Vivian Andrist. Eastham Historical Society. July 25, 1981.

Payne, Daniel G. Interview with the author. Henry Beston Society, July 2011.

Richardson, Leroy. Interview by Don Sparrow. Eastham Historical Society, September 7, 1989.

Sheahan, Marie. Interview with the author. Henry Beston Society, 2006.

Sparrow, Donald. "The Rumrunners of Cape Cod." Presentation to Eastham Elementary School, February 13, 1991.

Wilding, Don, Todd Kelley and Marcus Hendricks. "A Three Walk Series: Exploring the Native Lands of Monomoyick Territory." Harwich Conservation Trust, Harwich, Chatham and Orleans, Massachusetts. September–October 2015.

Books

Beston, Henry. *The Outermost House*. New York: Doubleday & Doran, 1928.

Burling, Francis. *The Birth of the Cape Cod National Seashore*. N.p: Eastern National, 1977.

Burrows, Frederika A. *Windmills on Cape Cod and the Islands*. Taunton, MA: Sullwold, 1978.

Clark, Arthur H. *The Clipper Ship Era: An Epitome of Famous American and British Clipper Ships, Their Owners, Builders, Commanders, and Crews, 1843–1869*. New York: Putnam, 1920.

Cornish, Roberta, and Marilyn Schofield. *Eastham*. Charleston, SC: Arcadia Publishing, 2003.

Dalton, J.W. *The Life Savers of Cape Cod*. Orleans, MA: Parnassus Imprints, 1991.

Digges, Jeremiah. *Cape Cod Pilot*. Provincetown, MA: Modern Pilgrim Press, 1937.

Doane, Alfred Alder. *The Doane Family and Their Descendants*. Salem, MA: Salem Press Company, 1902.

Emery, Edwin. *The History of Sanford, Maine*. Salem, MA: Salem Press Company, 1901.

Bibliography

Garrison, William Lloyd. *A House Dividing Against Itself, 1836–1840*. Cambridge, MA: Harvard University Press, 1971.

Goodspeed, Thomas Wakefield. *Gustavus Franklin Swift: 1839–1903*. [Chicago]: [1922].

Haven, Gilber, and Thomas Russell. *Incidents and Anecdotes of Reverend Edward T. Taylor: For Over Forty Years Pastor of the Seaman's Bethel, Boston*. Boston: B.B. Russell, 1873.

Lowe, Alice A. *Nauset on Cape Cod*. Eastham, MA: Eastham Historical Society, 1968.

Mitchell, J.H., and Whit Griswold. *Hiking Cape Cod*. Charlotte, NC: East Woods Press, 1978.

Noble, Dennis. *That Others Might Live*. Annapolis, MD: Naval Institute Press, 1994.

O'Connell, James C. *Becoming Cape Cod: Creating a Seaside Resort*. Lebanon, NH: University Press of New England, 2003.

Perry, E.G. *Trip Around Cape Cod*. Boston: self-published, 1898.

Richardson, Wyman, and Henry B. Kane. *The House on Nauset Marsh*. Woodstock, VT: Countryman Press, 2005.

Rothery, Agnes. *Cape Cod Old and New*. Boston: Houghton-Mifflin Company, 1918.

Sparrow, Donald. *A Cape Cod Native Returns*. Eastham, MA: Great Oaks Publishing, 2002.

———. *Growing Up on Cape Cod*. Eastham, MA: Great Oaks Publishing, 1999.

Tarbell, Arthur Wilson. *Cape Cod Ahoy!*. Boston: Little, Brown and Company, 1937.

Thoreau, Henry David. *Cape Cod*. Boston: Houghton, Mifflin and Company, 1898.

Newspapers, Magazines, Periodicals

Boston Globe. "Eastham Fold Get Rich Liquor Cargo." October 28, 1932.

———. February 10, 1934.

———. "Halloween Pranksters Return Victim's Turnips." November 2, 1938.

———. "Proposed Highways Please Cape Cod." November 25, 1934.

———. "Retired Blubber Hunter." November 6, 1904.

Brooks, S. Stewart. "Orleans Scenes." *Cape Codder*, March 21, 1968.

Bibliography

Cal, the Clam. "Memoirs of the Rum Runners." *Cape Codder*, December 6, 1951–January 17, 1952.

Cape Cod Central Railroad Company. *Backgrounds: Cape Cod's Golden Age of the Iron Horse*. N.d.

Cape Codder. "Crisp Speeches, Warm Sun, Launch Park." June 2, 1966.

———. "Eastham Had Real Old Fashioned Turnip Pull for Collins Sunday." November 15, 1951.

———. "How the Cape Cod National Seashore Was Born." May 19, 1966.

———. March 12, 1959.

———. November 8, 1956.

———. Obituary for Clarence Webster. September 1, 1979.

———. "Old Eastham Turnip Pull." August 16, 1951.

———. "Park Dedication at 2 o'clock Monday." May 26, 1966.

———. "Talk of Reopening Orleans Cable Station Next Year." September 12, 1946.

———. "'Unpublished' Piece of Thoreau Writing Is Uncovered in Eastham." August 21, 1947.

Cape Cod Standard-Times. "Cape Cod National Seashore Dedicated to Americans." May 26, 1966.

Coleman, David. "Jim Owens: Eastham's Windmill Man Has Many Talents." *Cape Codder*, n.d.

Coogan, Jim. "Captain Penniman and the Polar Bear." *Barnstable Patriot*, June 29, 2012.

Donaldson, William. "Annual Harvest Is About to Start for Eastham's Aristocratic Turnip." *Cape Codder*, October 14, 1986.

Heaton, Claude E. "The Indians Had a Name for It." *Cape Cod Compass*, 1967.

Jewell, Frederick. "Schoolhouse Museum Now Open at Eastham." *Cape Cod Standard-Times*, July 2, 1967.

Maynard, Mike. "Interview with Joseph Berbine." Coast Guard Heritage Museum Newsletter, Winter–Spring 2012.

Nickerson, W. Sears. "Land Ho! Pilgrims' Progress Along the Backside of Cape Cod." *Cape Codder*, June 6, 1957.

Orleans Historical Society. "150 Years: Rail to Trail." 2015.

Paine, Gustavus Swift. "Once upon a Time on Cape Cod: Captain Edward Penniman, Eastham Whaler." *Cape Codder*, March 8, 1951.

Provincetown Advocate. "Eastham—Surprise Party." January 1, 1880.

———. "Farewell to the Coast Guard." September 25, 1958.

Bibliography

"Remembering Eastham's Mr. Turnip." Ancestry.com, January 4, 2009. http://wc.rootsweb.ancestry.com/cgi-bin/igm.cgi?op=GET&db=oldmankew&id=I43139.

Sandwich Observer. May 2, 1911.

Seaman, Ken. "The Eastham Turnip Man." *Cape Codder*, January 15, 1993.

Sunday Standard-Times (New Bedford, MA). February 9, 1936.

Ullman, John, and Greg O'Brien. "Ehrlichman Launched Plumber Caper from VIP House on Eastham Dunes." *Cape Codder*, July 4, 1974.

Whalen, Ellen Petry. "The Eastham Turnip and Art Nickerson." *Edible Cape Cod*, September 10, 2009.

INDEX

A

Abbott, George 10
Abbott, Rosemary 10
Adams, John 73
Adams, Zenas 105
Allerton, John 19
Alpert, Kate (Moore) 11
Anna Sophia 73
Asparagus Acres 24
Aspinet 21, 128

B

Bancroft, George 52
Bangs, Edward 21
Bangs, Lt. Joshua 30
Barnstable Patriot 54, 93
Bates, Van Ness 124
beach apparatus 68
Bean, Ben 117
Bearse, Alonzo 67
Benner, Arthur 26
Berbine, Joseph 75
Beston, Henry 9, 29, 49, 58, 63, 66, 73, 107, 110, 125, 127, 129
Beyle, Noel 11

Bible, Senator Alan 123, 124
Billington, John 19
Blake, Richmond 26
Blanchard, Captain Hollis 72
Blizzard of '78 59
Boland, Representative Edward 122
Boonisar, Richard 66
Boston Globe 75, 92, 94, 116
Boston Post 40
Boston Transcript 37
Boynton, Stanley 26
Brackett, Raymond 26, 28
Bradford, William 17, 18, 19, 22, 128
breeches buoy 68, 69
Briggs, Edwin and Harrison 99
Brooks, S. Stewart 53
Broun, Maurice 99
Brown, James 75
Bryant, David 52
Burke, William 11, 107
Burling, Francis 119, 122, 123
Burrows, Frederika A. 31

C

Cabot, John 14
Cape Cod Canal 75

INDEX

Cape Cod Central Railroad Company 43, 46
Cape Codder 24, 25, 26, 33, 35, 36, 37, 46, 49, 53, 57, 58, 60, 81, 83, 99, 108, 116, 117, 119, 121, 122
Cape Cod National Seashore 10, 21, 22, 59, 61, 75, 92, 94, 99, 108, 113, 116, 122, 124, 125, 127
Cape Cod Standard-Times 89, 125, 128
Cape Hatteras National Seashore 120
Carter, Ray 80
Carver, John 19
Castagna 72
Chalke, Effin 70
Chalke, Helen 70
Champlain, Samuel de 14, 123
Chapel in the Pines 10, 97
Chase, Ralph 89
Chase, Wilbur 73, 105
Chatham Historical Society 57
Chatham Light 57
Chenoweth, Russ 11
Cicero 93
Civilian Conservation Corps 120
Clark, Arthur H. 99
Clark, Edward C. 101
Clarke, Jack 59
Clark, Eugene 89
Clark, Master Mate 19
Coast Guard Beach 59, 60
Coatsworth, Elizabeth 113
Cochran, Moncrieff M. 26
Cohen, Solomon 71
Cole, Daniel 22
Cole, Harold 33
Cole, Job 22
Coleman, Eugene 58
Cole, Timothy 101
Collins, Bernard 44, 45, 47, 69, 72, 89
Collins, Elizabeth M.A. 71
Collins, George 101
Collins, Harry W. 26, 128
Collins, Kenelm 45
Collins, Lewis 69, 72

Collins, Michael 50, 56
Collins, Peter 71
Connell, John A. 71
Conrad, Hawkins 49
Contest 99, 100
Coogan, Jim 93
Cook, Josias 21
Copin, Master Gunner 19
Cornish, Roberta 37
Coston flare 68
Cove Burying Ground 30
Cronin, Edward J. 128
Crosby's Tavern 101
Cummings, Mr. and Mrs. B.J. 54
Cummings, Prescott "Bud" 78, 79, 80, 81, 82, 83

D

Daley family 42
Dalton, J.W. 66
Daniels, Henry 80, 105
Del Deo, Josephine 124
Desmond, Thomas H. 120
DeVoto, Bernard 120
Digges, Jeremiah 63
Dill, George J. 71
Doane, Alfred Alder 21
Doane, Deacon John 15, 21
Doane, Ezekiel 23, 91, 104
Doane, Noah 108
Donaldson, William 25
Dotey, Edward 19
Dudley, Eliar 71

E

Eagles, Dave 11
Eastham Historical Commission 10
Eastham Historical Society 10, 11, 29, 50, 54, 101, 127
Eastham Oracle 31, 33
Eastham Tercentenary 127
Eastham Turnip Festival 28
Eastham Turnip Pull 26, 27

Index

Eastham Windmill 10, 29, 31
Edible Cape Cod 25
Edwards, Congressman Jack 117
Ehrlichman, John 116
Eighteenth Amendment 77, 83
Eisenhower, President Dwight D. 120
Eldredge, William 105
Ellison, Ian 35
Ellsburg Caper 117
Emerson, Ralph Waldo 50
Emery, Edwin 65
English, Thomas 19
Europa 93, 94, 96
Expert House Movers 60

F

faking box 68
Faraday 53
Faunce, John 65
Faunce, John 65
Finch, Robert 113
First Comers 127
First Encounter 10, 19
First Encounter Coffeehouse 97
First Universalist Church of Eastham 96
Fitzgerald, Michael 100
Flying Santa 58
Fogg, Senator Hiriam 123
Foster, Charles H.W. 123
Fraser, Doug 61
Freeman, Isaac 91
Freeman, John 22
French Telegraph Cable Company 53
Fresnel lens 52, 58
Friedrich 71
Fulcher, Ezekiel, Jr. 104
Fulcher, John 103, 104
Fulcher, John, Jr. 31, 33
Fulcher, Josephine Helena (Doane) 104
Fulcher, Obed 104

G

Garrison, Lon 125
Garrison, William Lloyd 40
Gill, Adin 53
Gill, Nathan 53, 56
Gilmore, Andrea M. 92, 93, 94
Gosnold, Bartholomew 14
Gould, Dan 105
Grant, President Ulysses S. 44
Greaney, Dianne 43, 44, 45
Great Plague of 1616–18 16
Griswold, Whit 70
Grover, Kathryn 23, 24
Gwirtzman, Milton 123

H

Hall, Albert and Mary 56
Hardy, Grace 57
Harper, Edwin 117
Haskins, Allison G. 58
Hatch, Captain Freeman 91, 99, 100
Hatch, Freeman 33, 35
Hautenan, Henry 75
Haven, Gilbert 40
Henderson, Eleanor 58
Hendricks, Marcus 13, 22
Henry Beston Society 10
Herbolt, George 56
Hereford, Mayor Walter E. 128
Higgins, Anna Maria 42
Higgins, John 33
Higgins, Peter 56
Higgins, Richard 21
Highland Light 49
Hix, Samuel 22
Hobbs, Malcolm 121
Holborn, Fred 122
Hopkins, Dr. L. Thomas 119
Hopkins, Stephen 19
Hopper, Edward 97
Horton, Charlie 25
Horton, Edwin W. 72
House on Nauset Marsh, The 108

INDEX

Howard, Dr. Herbert 119
Howard, George 128
Howland, John 19
Huckins, James 99, 100
Humphrey, Vice President Hubert 125
Hunt, Thomas 16
Hurd, Luther 91

I

International Chimney Corporation 60
Isabella 92

J

Jacob A. Howland 93, 96
James, William 128
Jenkins, John 22
Jennison, Isaac 40
Jewell, Frederick 85, 88, 89
J.H. Ells 71
Johnson, President Lyndon 125
Jones, Captain Christopher 16

K

Kasparian, Lance 66
Katie Barrett 71
Keegan, C.D. 67
Keith, Representative Hastings 122, 123
Kelley, Thomas 56
Kelley, Todd 13, 16
Kelly, Suan Annie 71
Kennedy, President John F. 124
Kennedy, Senator Edward 124
Kennedy, Senator John F. 122
Kimball, Sumner I. 65, 66
King James 22
King, Joe 28, 80
King Philip's War 22
Knowles, Captain Samuel 104
Knowles, Captain Winslow 100
Knowles, C. Winfield 46, 47
Knowles, Flora 108
Knowles, Joshua 42
Knowles, Seth 23, 30
Knowles, Squire Harding 101
Knowles, Thomas 92

L

Lee, Joan 60
Lee, Ronald 123
Lewis, Captain Winslow 51, 52
Lewis, I.W.P. 50
Lewis, Stephen 56
Lifesavers of Cape Cod, the 66
Lincoln, Joseph 71
Lindberg, Charles 53
Lindholm, Rick 71
Lowe, Alice A. 13, 24, 30, 45, 49, 53, 66, 67, 71, 85, 93, 94, 99, 101, 103, 105
Lyle gun 68, 69

M

Magruder, Jeb Stuart 117
Mailer, Norman 97
Malle-barre 14
Margaret 103, 104
Maroney, Edward F. 57
Martin, David 122
Massachusetts Humane Society 64
Mayflower 16, 17, 103, 127, 128
Maynard, Mike 105
Mayo, Abijah 44
Mayo, Captain Matthew Hopkins "Hoppy" 91, 100, 101
Mayo, Freeman Doane 103
Mayo, Kenneth 115
Mayo, Reverend John 128
Mel-Con development company 123
Methodist Episcopal Church 39
Meyers, Harry 44
Milford, Connecticut 22
Millennium Grove 37, 40, 41, 42
Miller, Lewis W. 128
Minerva 93
Mission 66 120, 121, 124

INDEX

Mitchell, J.H. 70
Moby Dick 40
Moffett, Ross 124
Monomoyicks 16
Montclair 73
Monts, Sieur de 14
Moore, Harvey 111
Moore, Jonathan 113, 122, 123
Morgenthau, Henry 63, 64

N

Nasi, Thomas 88
National Environmental Educational Development 75
National Park Service Organic Act 119
National Register of Historic Places 90
Native Land Conservancy 13
Nauset Fellowship (Universalist-Unitarian) 97
Nauset Light 10, 49, 56, 59, 61, 127
Nauset Light Preservation Society 10, 49, 60, 61
Nauset Purchase 21
Nauset Regional High School 35
Nickerson, Arthur 23, 25, 28, 77, 80
Nickerson, George 25, 27
Nickerson, George B. 63, 67, 73, 75
Nickerson, Otto 86, 111
Nickerson, Reuben 23
Nickerson, Samuel 42
Nickerson, William 14
Nickerson, W. Sears 16, 18
Nobili, Conrad 60
Nobili, Pam 60
Noble, Dr. Dennis 66
Northern Light 99, 100

O

O'Connell, James 40, 120
O'Connor, William D. 66
Old Colony Railroad 23, 43
Old Comers 17

O'Neill, Representative Thomas "Tip" 122
Ormsby, Ralph 75
Outermost House, The 10, 29, 33, 49, 63, 66, 73, 113, 125
Owens, Jim 11, 29, 30, 31, 33, 35, 36

P

Packard, David 117
Packwood, Senator Robert 117
Paine, Gustavas Swift 99
Paine, Nicholas 30
Paine, Thomas K. 29, 31
Palmer, George 113, 122
Payne, Daniel G. 110
Peabody, Governor Endicott 113
Penniman, Betsy Mayo "Gustie" 92, 93, 96
Penniman, Captain Edward 91, 92, 93, 94, 96, 97, 99
Penniman, Daniel 92
Penniman, Eugene 91
Penniman, Irma 99
Penniman, Scammel 92
Percival, Captain John "Mad Jack" 51
Perry, E.G. 24, 91
Peterson, Ron 66
Philbin, Representative Philip J. 122
Pierce, Marcus M. 67
Pilgrims 16
Pilgrims Crossing 124
Plante, Beverly (Campbell) 11
Pleasanton, Stephen 52
Plumbers, The 116
Pollock Rip 16
Portland 71
Port Society of Boston 40
Poutrincourt, Sieur de 15, 16
Poyner, John 56
Pratt, Enoch 30
Prence, Thomas 21, 104, 128
Prohibition era 77, 83
Provincetown Advocate 51, 75
Purchasers, the 21, 42

Index

Q

Quinn, Howard 35

R

Reeser, George C. 105
Richardson, Elliot 109, 113, 122
Richardson, Leroy 80, 81, 82
Richardson, Maurice 108, 110
Richardson, Wyman 107, 108
Rich, Jabez 101
Rich, Shubah 29
Ripley's Believe It or Not! 92
Robinson, Harry C. 71
Rogers, Joseph 22
Rogers, Ralph L. 128
Rongner, George 11, 86, 100, 111, 115, 116
Rongner, Yngve 75, 111
Roosevelt, James 116
Roosevelt, President Franklin D. 64, 115, 116, 120
Roosevelt, President Theodore 115
Rothery, Agnes 37, 39
Rowell, Lucian 58
Rowell, Miriam 58, 59
Rum Row 79
rumrunners 77, 78, 81, 82
Rumsfeld, Donald 117
Russell, Thomas 40

S

Sabin, Shirley 57, 58
Saltonstall, Senator Leverett 113, 122
Salt Pond Visitors Center 22, 59
Schofield, Marilyn 37
Schweiker, Senator Robert 117
Seaman, Ken 25
Seamen's Bethel 40
Seaquanset 16
Serpa, Jules 75
Shaw, William 58
Sheahan, George 110
Sheahan, Marie 110
Shenandoah 93
Shook, Fay 50, 54
Silva, Steve 31, 33
Smalley, Captain Orrick 92
Smalley, John 21
Small, Isaac M. 73
Smart, Matilda 101
Smith, Captain John 16, 17
Smith, Lamont 45
Smith, Luther P. 128
Smith, Senator Benjamin 123
Snow, Albert E. 71
Snow, Edward Rowe 50, 58
Snow, Frederick Warren 72
Snow, Nicholas 21
Snow, Ralph Linwood 106
Sotten, Eva M. 71
Sparrow, Don 11, 28, 33, 78, 79, 80, 81, 82, 85, 86, 115, 116
Sparrow, Fenton 24, 33, 115
Sparrow, Obed 101
Sparrow, Reta (Cummings) 82
Sparrow, Robert 89, 115
Spears, Edgar 104
Squanto 16
Standish, Myles 17, 19, 128
Stone, Massachusetts Senator Edward C. 121
Sullivan, H.M. 46
Swift, Gustavus 42
Swift, Nathaniel 42

T

Tarbell, Arthur Wilson 24
Taylor, Reverend Edward T. 40
Taylor, Russell 105
Tercentenary celebration 127
Thoreau, Henry David 40, 41, 51, 107, 108, 119
Three Sisters of Nauset 10, 49, 50, 51, 53, 54
Thumpertown 37, 42
Tilley, Edward 19

INDEX

Tilley, John 19
Treat, Reverend Samuel 22, 124, 128
Treat's Hill 22
Twenty-First Amendment 83

U

Udall, Stewart 122, 124
Ullman, John 36
USS *S-19* 105

V

vanRoden, Mary Daubenspeck 51, 52, 59, 61
Viedler, Fred S. 58
Village Improvement Society 31, 33
VIP House 116
Volpe, Governor John 35, 124
Vonnegut, Kurt 113

W

Waldron, Nan Turner 9
Walker, Abbott H. 67, 105, 106
Walker, Peter 101
Wampanoags 13
Wardens of Cape Cod, the 110
War of 1812 40, 100
Warren, Richard 19
Watson, Robert 115
Watson, William 115
Webster, Jack 33, 35, 36
Weiss, Ellen 40
Whalen, Ellen Petry 25
Wheeler, Anna Augusta 71
Wiley, Maurice 24, 26, 122, 128
Windmill Literary Society 33
Windmill Station 36
Windmill Weekend 10, 36, 127
Winslow, Edward 19
Wirth, Conrad 120, 123
Wixam, Robert 22
Wonderstrand 14

Y

Yates, James 56
Young, Kenneth 105

About the Author

Since the start of the millennium, Don Wilding has been telling stories of Cape Cod Outer Beach history through lectures and the written word. An award-winning writer and editor for Massachusetts newspapers for thirty years, Don contributes the "Shore Lore" history column for the *Cape Codder* newspaper of Orleans and is the author of the book *Henry Beston's Cape Cod: How* The Outermost House *Inspired a National Seashore*, for the Henry Beston Society. His Cape Cod history lectures are a popular draw on Cape Cod and across Massachusetts.

Don is a co-founder of the Beston Society and is on the board of directors for the Eastham Historical Society. He lives with his wife, Nita, in Northbridge, Massachusetts, and on Cape Cod.

dwcapecod.com
donwildingscapecod@gmail.com